# Borges 2.0

# LATIN AMERICA
## Interdisciplinary Studies

Gladys M. Varona-Lacey
*General Editor*

Vol. 13

PETER LANG
New York • Washington, D.C./Baltimore • Bern
Frankfurt am Main • Berlin • Brussels • Vienna • Oxford

Perla Sassón-Henry

# Borges 2.0

## From Text to Virtual Worlds

PETER LANG
New York • Washington, D.C./Baltimore • Bern
Frankfurt am Main • Berlin • Brussels • Vienna • Oxford

**Library of Congress Cataloging-in-Publication Data**

Sassón-Henry, Perla.
Borges 2.0: from text to virtual worlds / Perla Sassón-Henry.
p. cm. — (Latin America; v. 13)
Includes bibliographical references and index.
1. Borges, Jorge Luis, 1899—1986—Criticism and interpretation.
2. Literature and technology. 3. Literature and science.
I. Title. II. Title: Borges two point o.
PQ7797.B635Z916455  868'.6209—dc22  2007005854
ISBN 978-0-8204-9714-3
ISSN 1524-7805

Bibliographic information published by **Die Deutsche Bibliothek**.
**Die Deutsche Bibliothek** lists this publication in the "Deutsche
Nationalbibliografie"; detailed bibliographic data is available
on the Internet at http://dnb.ddb.de/.

The paper in this book meets the guidelines for permanence and durability
of the Committee on Production Guidelines for Book Longevity
of the Council of Library Resources.

© 2007 Peter Lang Publishing, Inc., New York
29 Broadway, 18th floor, New York, NY 10006
www.peterlang.com

Printed in Germany

To my parents

# Table of Contents

# Acknowledgments

Many friends and colleagues assisted me in bringing this book to fruition.

I would like to express my gratitude to Donald Byrd, Helen Regueiro Elam, and Warren Ginsberg as members of my dissertation committee at the State University of New York at Albany.

A special thank you goes to Stuart Moulthrop whose works provided me with an outstanding source of inspiration for this project. His sage and detailed comments on the very early stages of this manuscript and warm advocacy throughout it encouraged me to move forward.

I am also grateful to Natalie Bookchin whose work and conversation with me about her work enabled me to see details I would have otherwise overlooked.

Katherine Hayles, a leading authority in digital text studies, generously gave me her time to discuss some aspects of this project, specially the chapter on "The Interloper."

Marjorie Luesebrink also read the chapter on "The Interloper" and provided me with insightful comments and ideas that contributed to strengthen the section on the relationship between digital media and Jorge Luis Borges's work.

I cannot but praise the scholarly and moral support I received from my colleagues from the Language Studies Department at the United States Naval Academy. Many of them read chapters at different stages and provided me with comments to add clarity to my work; any errors remaining are mine. The staff of the Nimitz Library, especially Florene Todd, from interlibrary loan, and Patti Patterson were instrumental in making this book. They were unfailingly supportive of my many requests for books and articles. The Naval Academy Research Council and the Naval Academy Office of Academic Research provided me with funds to support my research and to bring this book to its final form.

I wish to thank Heather Dubnick for her unwavering professionalism and her considerable help and advice in editing and formatting this volume.

In somewhat different form, chapters of this book have appeared as essays. I thank each journal for having granted me permission to reprint them. Sections of Chapter 3 and 4 appeared in "Borges and his legacy in Hyperfiction: A Study Through the lenses of Deleuze and Guattari's Rhizome Theory" in *Latin American Essays,* Volume 18, (2005): 148–156. A sections of Chapter 7 appeared as "Borges' "The Library of Babel" and Moulthrop's Cybertext

"Reagan Library" Revisited," in *Rocky Mountain E- Review of Language and Literature,* Volume 60, Number 2, (Fall 2006) and *Rocky Mountain Review of Language and Literature,* Volume 60, Number 2, (Fall 2006): 11–22. Another section of Chapter 7 appeared previously as "Chaos Theory, Hypertext, and Reading Borges and Moulthrop, in *CLC Web* Comparative Literature and Culture 8.1(2006): <http://clcwebjournal.lib.purdue.edu/clcweb06–1/sasson-henry06.html> © Purdue University Press. Chapter 8 was published as "North Meets South: Jorge Luis Borges's "La Intrusa" and Natalie Bookchin's Media Experiment *The Intruder"* in *Latin American Essays,* Volume 19, (2006): 159–169.

I want to thank Grove Press for having granted me permission to use sections from the Prologue, "The Library of Babel" and "The Garden of Forking Paths" from *Ficciones* by Jorge Luis Borges, edited and with and introduction by Anthony Kerrigan, New York: Grove Press, 1962. I also extend my appreciation to Penguin Group (CA) for having granted me permission to use from *Collected Fictions* by Jorge Luis Borges. Copyright © Maria Kodama, 1998. Translation and notes copyright© Penguin Putnam Inc., 1998. Reprinted by permission of Penguin Group (Canada), a division of Pearson Canada Inc. Also thank you to Penguin Group (UK) for permission to use approximately 328 words from COLLECTED FICTIONS by Jorge Luis Borges, translated by Andrew Hurley (Penguin, 1998) Copyright © Maria Kodama, 1998. Translation and notes © Penguin Putnam Inc, 1998. I also want to thank Penguin (USA) Inc. for permission to use material from "The Interloper," from COLLECTED FICTIONS by Jorge Luis Borges, translated by Andrew Hurley, copyright© 1998 by Maria Kodama; translation copyright © 1998 by Penguin Putnam Inc. Used by permission of Viking Penguin, a division of Penguin Group (USA) Inc.

Above all, I am indebted to my husband, Ben, whose contributions from the inception of this book to the selection of the title are too many to mention and to acknowledge with just a *thank you.*

# Prologue

# Bridging the Gap

As happened with the invention of the printing press, the widespread use of computers has affected not only our social interaction but also our learning process and our ideas about books. These rapid technological changes challenge readers, writers, and scholars from different fields to reconsider the need to bridge the gap between science, technology, and the humanities to benefit from the capabilities present in hypermedia environments to interpret printed literature from a new perspective.

Within this framework, *Borges 2.0: From Text to Virtual Worlds* provides a critical analysis of some of Jorge Luis Borges's most fascinating stories—"The Garden of Forking Paths (1941)," "The Library of Babel" (1941), and "The Interloper" (1966)—from the point of view of their intricate relationship to science and technology.[1] My argument is grounded on the assumption that a study of these Borgesian stories through the lenses of science and technology via the theories of Gilles Deleuze, Félix Guattari, and Umberto Eco will provide a new approach to understanding Borges's work in the twenty-first century. Bearing in mind Borges's futuristic views concerning the idea of chaos and multiple times, one easily apprehends the connections between Borges's work, technology, science, hyperfiction, and new multimedia applications such as net art and video games. Moreover, Borges's position in reference to the reader, writer, and the text grounds his definition of literature, turning it into a realm inevitably affected by the time of its reading, as Borges clearly stated in his essay "A Note on (toward) Bernard Shaw":

> One literature differs from another, prior or posterior, less because of the text than because of the way in which it is read. If I were granted the possibility of reading any present-day page—this one for example—as it will be read in the year two thousand, I would know what literature of the year two thousand will be like. ("A Note on (toward) Bernard Shaw" 164)

Development of this book has been continuously inspired and challenged by the contemporary accelerating pace of technological change. These changes have illuminated more perspectives from which to interpret Borges's short stories. The title *Borges 2.0: From Text to Virtual Worlds* evokes ideas from "Web 2.0," a concept which refers to a more decentralized and collaborative Web that, like a Borgesian fiction, calls for active user/reader participation.[2] Chapter 1 describes the existent relationship between computers and

the humanities towards the end of the twentieth century. It also traces the points of convergence among oral literacy, hypertext, and Borges's interpretation of the roles of the reader, the text, and the writer. In Chapter 2, I explore the connection between hypertext electronic links and Borges's *forking paths*. Michael Joyce's seminal piece *afternoon: a story* serves as a springboard to elaborate on the similarities and differences between digital links and the Borgesian *forking paths* as portrayed in "The Garden of Forking Paths."

From Foucault's theoretical standpoint in his essay "Language to Infinity," which I refer to in order to illustrate the power of language in Borges's forking paths, I turn to the theories of Gilles Deleuze, Félix Guattari, and Umberto Eco. Thus, Chapter 3 develops as an interwoven space where Deleuze and Guattari's theoretical framework as established in *A Thousand Plateaus: Capitalism and Schizophrenia* meets Eco's theory of the open work. These theoreticians' works provide the framework to analyze Borges's fiction through the lenses of hypertext, Deleuze and Guattari's rhizomatic theory, and Eco's classification of labyrinths. In this sense, Chapter 4 focuses on the analysis of "The Library of Babel," "The Garden of Forking Paths," and the World Wide Web as rhizomatic and hypertextual environments. Whereas the first part of the chapter highlights the points of convergence and divergence in "The Library of Babel" and the World Wide Web as postmodern, decentralized, and kinetic worlds, the second part of this chapter emphasizes the struggle between logos and nomos as described by Deleuze and Guattari and applied to "The Garden of Forking Paths" and the World Wide Web.

In Chapter 5, I return to Eco's theory of labyrinths to analyze "The Library of Babel," "The Garden of Forking Paths," and the World Wide Web as mazes and labyrinthine nets. In this light, these two Borges stories are seen as literary machines whose meanings exceed their texts. As a natural bifurcation in this study, Chapter 6 leads the reader to a new terrain where literature, science, and technology interact, creating a new space to discuss Borges's short stories. In this section I argue that there exists a tripartite relationship among Borges's texts, Moulthrop's *Victory Garden,* and chaos theory. The emphasis on the dialogue among these texts via chaos theory, bifurcation theory, and noise distinguishes this analysis from earlier studies. By underscoring the reciprocal interconnectedness among Borges's stories, *Victory Garden,* scientific theory, and new media, I also acknowledge the intricate connections among print literature, digital literature, and science, and thus move towards a new interpretation of Borges's oeuvre, one that

reaffirms Borges significant role in Latin American literature and culture while acknowledging its projection into the digital age.

This constant dialogue among theory, technology, and literature is also underscored in Chapter 7, where I once again draw from Stuart Moulthrop's insights in his cybertext "Reagan Library" to illustrate the intimate relationship between Moulthrop's and Borges's work within the framework of chaos theory and bifurcation theory. Finally, in Chapter 8, I bring to the fore the alluring but also dark features of Borges's "The Interloper," which has captured the attention of media artist and scholar Natalie Bookchin. In her media experiment *The Intruder,* Bookchin mediates Borges's short story via electronic text, audio files, and a sequence of arcade video games which underscore the female character's fate.

Bookchin's *The Intruder* as well as Moulthrop's *Victory Garden* and "Reagan Library" have opened a new space for the interpretation of Borges's fiction: one that acknowledges the crucial role of literary criticism, science, and technology as represented by the evolving genre of electronic literature and video games. The path started by Borges, hyperfiction writers, and net artists has just begun to be explored. It is up to the present and future generation of scholars to engage in the fascinating process of creating and understanding works of literature that are deeply "intertwingled"[3] with technology as they challenge writers and readers to constantly develop new modes of reading, writing and interpretation.

## Notes

1   Jorge Luis Borges's short story "La intrusa" appeared in English in 1970 in the volume *The Aleph and Other Stories* which was edited and translated by Norman Thomas di Giovanni in collaboration with the author. In that volume "La intrusa" was preferably translated as "The Intruder." Due to copyright restrictions I cite "The Intruder" as "The Interloper" title that appears in *Collected Fictions* translated by Andrew Hurley.

2   For a detailed explanation of the concept Web 2.0, see http://www.oreilly.com/tim/news/2005/09/30/what-is-web-20.html.

3   Term used by Ted Nelson to refer to the interconnectivity of texts. For further reference, see *Computer Lib: Dream Machines* 31.

# Chapter 1

# Computers, Hypermedia, and the Humanities

## Chronological Perspective

Humanity faces one of the most astonishing technological revolutions: the widespread use of electronic communication with a rapid deployment of hypermedia systems. The most well-known hypermedia system, the World Wide Web, is conceived as a seamless world in which information, from any source, can be accessed in a consistent and simple way. The Web uses hypertext as the method of presentation of documents that can be text, graphics, movies, and sound (Berners-Lee). On December 19, 2005, Jakob Nielsen's Web site "Alertbox: Current Issues on Web Usability" announced that "Some time in 2005, we quietly passed a dramatic milestone in Internet history: the one-billionth user went online" (Nielsen par. 1). In spite of the staggering number of users connected to the Internet, still only relatively few have exploited the potential of this environment for literary studies. As days go by, the number of advocates in the realm of humanistic studies increases. Some scholars have invested a great portion of their lives to study literature and technology, and the present moment provides them an oasis of possibilities to explore creative writing and the interpretation of literary texts by taking into account the characteristics of the new medium. Because the preservation of early pieces is as important as the development of new literary pieces, the Electronic Literature Organization has already undertaken the task of digitally archiving works to promote their preservation and academic use.[1]

The search for new modes of expressions that dare to overflow the constraints of print began with several world-renowned writers who, before the advent of the digital space as a medium for writing, envisioned literary pieces that embody some characteristics of hypertext and the World Wide Web. Julio Cortázar's *Hopscotch* and Jorge Luis Borges's "The Garden of Forking Paths" fall within this category because they foster the emergence of multiple stories from the text. "The Library of Babel" underscores Borges's visionary reference to an almost unlimited library that, like the World Wide Web, seems to hold all the answers to man's concerns. Studied from a perspective that acknowledges the features of hypertext and the World Wide Web, these works acquire new meanings that up to this moment have been overlooked. What I will trace in this introductory chapter are the historical issues related to the emergence of hypertext and its relationship with the oral

tradition and the humanities. This framework will provide the foundations to study the relationship between hypertext and Borges's ideas concerning the reader, the writer, and the text.

## Reaction to the New Medium

As with Gutenberg's invention of the printing press in the fifteenth century and other points of important change in history, the new technology has advanced accompanied by its visionaries, advocates, and opponents. There are those like David Riesman who, back in 1955, questioned the power of the new media, asserting that books were "fighting words, the gunpowder of the mind" (40). In his address delivered at Antioch College on October 5, 1955, Riesman asked "[W]hat will be the significance of the written word now that newer mass media less demanding psychologically and yet perhaps more potent politically have developed[?]" (3); yet, he finished his speech acknowledging that books "serve along with newer and the still older media to individualize, entertain and broaden [readers]" (40).

Many of those unimpressed by the new technology fear either the loss of intellectual thinking and/or the disappearance of the book in its printed form. In the afterword of *The Future of the Book,* Umberto Eco asserts that the idea that "something will kill something else is a very ancient one, and came certainly before Hugo and before the late medieval fears of Friollo" (295). Eco continues with his argument stating that

> [a]ccording to Plato (in the *Phaedrus*), Theut, or Hermes, the alleged inventor of writing, presents his invention to the pharaoh Thamus, praising his new technique that will allow human beings to remember what they would otherwise forget....My skillful Theut, he says, memory is a great gift that ought to be kept alive continuously, with your invention people will not be obliged any longer to train memory. They will remember things not because of an internal effort but by mere virtue of an external device. (295)

As Eco explains, "we can understand the pharaoh's worries" (296). The pharaoh states that "writing, as any other new technological device, would have made torpid the human power that it replaced and reinforced" (296). From the pharaoh's perspective, "writing was dangerous because it decreased the powers of the mind, offering human beings a petrified soul, a caricature of mind, a vegetal memory" (296). From Eco's perspective, Plato took a similar stance in the *Phaedrus* where he considers that "written speech might fairly be called a kind of shadow" in reference to animate speech (98).

In spite of the controversy and opposition generated by technology at different points in time, those who study the hard sciences, as well as some

humanists, keep developing new machines and software that are changing the ways scholars and students study literature. Today, hypertext, hypermedia environments, and video games are commonplace words that have been recognized by scholars as mediums to create and recreate literary narratives.

## The Origins of Hypertext

The origins of hypertext can be traced back to the article "As We May Think" written by Vanevar Bush in 1945. In this article, Bush envisioned a machine called the "memex," which could supplement man's memory and would imitate man's processes of association. The main difference between the "memex" and man's memory would be the clarity and permanence of the information retrieved by storage. Douglas Engelbart's research and later prototype of a hypertext system called AUGMENT materialized Bush's prophecy. Hence, Engelbart was among the first to acknowledge the fundamentals and value of computer interaction, writing and networking, outlining, windows, electronic mail, computer conferencing, and collaborative authoring. It was Ted Nelson who coined the term "hypertext" and who designed an ongoing project in his Xanadu System[2] to promote the establishment of "intertwingled" and computerized texts on earth.

All this development of hypertext seemed to fall short for hyperfiction writer Michael Joyce, whose dream was to write a novel that could change in every reading as a result of the paths followed by the reader.[3] In order to make his dream come true, Joyce, together with Jay Bolter and Bolter's colleague John Smith, created StorySpace in 1986, a hypertextual authoring system that allowed Joyce to write the first electronic hyperfiction: *afternoon, a story*. This authoring system, though not the only one available today, opened the doors to a new genre called hyperfiction, which exploits the linking capabilities of hypertext. At around the same time, Moulthrop developed "forking paths": "a hypertextual treatment of Borges' story ["The Garden of Forking Paths"] originally intended as a demonstration for an advanced undergraduate course in narrative theory" ("Reading from the Map" 124). This work, which was created in a pre-release or beta version of StorySpace, "was not meant as literary pastiche but as probe or provocation, confronting a group of very bright students with the problem of hypertextual practice: while print may dream of multi-threaded, polymorphous texts, electronic fictions must inhabit such worlds in reality; and we with them" ("Anatomy"). Though, "forking paths" was never commercialized due to obvious copyright issues, it became one of the first hypertexts to directly

"represent a hypertextual realization of Borges' textual theorizing" ("Reading from the Map" 124).[4]

## Hypertext in the Humanities

Ted Nelson's visionary statement that literature is a "system of interconnected writings" (*Literary Machines* 2/9) subliminally suggests the tight bond between computer science and the humanities. If literature is to fulfill Nelson's prediction, then concrete projects have to be developed by multidisciplinary teams. A clear example of this is George Landow's Victorian Web, which is the WWW translation of Brown University's Context 61, a course in Victorian Literature, and which serves as a resource for Victorian literature courses at Brown University.[5] In addition, the Victorian Web project has also inherited some of its contextual information from Context 32, a course taught at Brown University entitled "Survey of English literature from 1700 to the Present." This course, which was begun in Spring 1985 as part of Brown University's Institute for Research in Information and Scholarship (IRIS) Intermedia project, was funded by IBM, Apple Computers, the Annenberg/CPB Project, and other sources (Landow, "Victorian Web"). Beginning in January 2000, the University Scholars Programme (USP) at the National University of Singapore has supported the Victorian Web, which is frequently updated with contributions of scholars from around the world. Since its inception, the Victorian Web has provided scholars and students from different fields with an invaluable array of sources that contribute to a multidisciplinary approach to the study of Victorian literature.[6]

Another groundbreaking project that uses technology to disseminate humanistic studies is the Perseus project, which started in 1987 at Harvard University with contributions from other educational institutions. It contains an extensive multimedia database with sources to study ancient Greece.[7]

According to George Landow and Paul Delany, two of the first scholars to acknowledge the use of hypertext and hypermedia in literary studies, "[h]ypertext can be defined as the use of the computer to transcend the linear, bounded and fixed qualities of the traditional written text" (*Hypermedia and Literary Studies* 3). Landow and Delany write that "unlike the static form of the book, a hypertext can be composed, and read, non-sequentially; it is a variable structure composed of blocks of text (or what Roland Barthes terms *lexia*) and the electronic links that join them" (3). The reading within each block resembles conventional reading, but once the reader starts making connections and moves from one lexia to another, a new reading experience evolves. Graphic representations in the forms of trees, webs, or Chinese boxes allow the reader to picture the structure behind the screen. These

metaphors serve to direct the reader in the navigational and reading process.[8] The reading within each book resembles a conventional reading, but once the reader starts making connections and moves from one lexia to another, a new reading experience evolves.

Rapid advances in technology have taken us one step further and have included hypertext within a system that integrates audio, video, and text. This system is called *hypermedia* and is nowadays popularly represented by the World Wide Web. Hypermedia extends hypertext by integrating our visual and auditory faculties into a textual experience, linking graphic images, sound, and video to verbal signs. According to Landow and Delany, by approximating the way our mind works, hypermedia seeks to synthesize the "information received from all five senses" (7).

*Hypertext* is a general term that applies to as many different kinds of works or text objects as printing technology does. When considering the implications and challenges of hypertext for literary studies, one must consider that hypertext can take different forms, such as stand-alone or networked systems. Each of these systems can in turn take the form of an exploratory or a creative hypertext. Whereas exploratory hypertexts are read-only documents, creative hypertexts allow readers to write annotations within the document or to create links to other documents within a network. In this study, I will refer to the stand-alone as well as to the networked systems so that I may elaborate on the intricate connection between the development of Borgesian digital artifacts at the turn of the twentieth century and at the beginning of the twenty-first century, a period that has been marked by rapid advances in hypermedia environments. Whereas networked environments such as the World Wide Web will allow me to relate the concept of "language to infinity" proposed by Michel Foucault[9] to Borges's theory of reading, I will also refer to exploratory and creative hypertexts for the possibilities they offer from the pedagogical and theoretical perspectives. From the pedagogical standpoint, hypermedia offers a wide array of easily accessible information that promotes an interdisciplinary approach when studying the humanities. From the theoretical perspective, hypermedia entices the reader to look beyond the plateau of plot to examine in a new light the structural possibilities of texts.

## Hypertext/Hypermedia: Features

Only once in many years does a new idea appear that penetrates the way we learn, teach and structure our knowledge, and which gradually pervades the fall spectrum of media. Hypermedia and multimedia applications represent such a pervasive idea.

Piet A. M. Kommers, *Hypermedia Learning Environments: Instructional Design and Integration*

Hypermedia is an extension of hypertext that includes text in the form of printed words, still images, video, and sound. This combination of different types of text and its unique capabilities makes hypermedia a powerful tool for the study of the humanities. In this section, I will refer to the features of hypermedia and later describe how they affect the process of understanding literature from a new perspective.

Hypermedia is a system that fosters the association of ideas through a linking process that imitates the way our mind works. While navigating in a hypermedia environment, readers can easily make connections between literary works and related subjects, thus helping readers to get a better understanding of the work in question and creating an infinite number of new mental constructs.[10] According to Piet A. M. Kommers, "the most prominent feature of hypermedia is the search facility in reference documents. Paper-based documents are restricted to text, tables, schematic line drawings, pictures and index lists, whereas hypermedia allows for sound and video as well. Surpassing paper-based resources, hypermedia gives a full priority to the multiple dimensions in the meanings of expressed ideas" (20). This feature is what Kommers calls "the resource metaphor." In his opinion, the "resource metaphor" "amplifies the notion that we can isolate information in some form so that it represents *what* has to be learned. You can take it with you, give it to someone else, copy it, and so forth" (21). By having easy access to an almost an unlimited database, readers can relate the text in question to innumerable nodes that can act as catalysts in the thinking process.

Another important characteristic of hypermedia is its capability to foster interaction. This interaction can take a variety of forms. One of these forms is represented by the interaction between students and what they see on the computer display. In order to make this experience a valuable one within the humanities, it is not enough to refer to the quick retrieval of texts or to texts that can contribute to the understanding of a literary work. The issue at stake here, particularly when dealing with hyperfiction and its connection to Borges's works, is not to take for granted whatever is given to us through the electronic mode but to question why such information has been given. At a time when information seems to come to us with almost no intellectual

effort, it is essential to adopt a critical perspective. In the essay "The End of Philosophy and the Task of Thinking," Martin Heidegger says, "philosophy is ending in the present age" (58). Heidegger does not mean that philosophy has died but that the technology of our time "characterizes and regulates the appearance of the world and the position of man in it" (58). The rapid evolving history of hypermedia systems calls for a rethinking of the way we use and understand technology. This point of view encourages us to take a suspicious yet inquisitive position in reference to the transparent language provided to us by the computer display.

Even though Heidegger's ideas sound pessimistic in an age mesmerized by computer technologies, they open up the field for discussion on the value of the features of the electronic hypertext or hypermedia systems when used for literary studies, especially when establishing connections between the new media, science, and Borges's fictions. It seems that language that is presented to us in a transparent fashion leaves no room for exploration, but what about questioning the appearance or existence of that language? What about thinking about the Other—the language that has not been made available to us? One of the interesting features of hypertext is that it allows the reader to see one particular version of a text, while many other possibilities lurk behind that image. In fact, some of the most challenging spaces for thinking are those that are not visible to the naked eye but latent or likely to emerge in future readings. Each new arrangement creates a new text, opening the possibility of the Other.

According to Gerald L. Bruns, "Heidegger speaks of bringing [us] to a 'place of being' of language, its essential place, but this it turns out is not so much a place as an event" (56). Something similar occurs in the process of analyzing a literary hypertext or net art, where the artifact becomes through doing. It is through the actual interaction between the text and its reader, the net art and its audience, that the artifact is created and recreated. Moreover, it is the actual ergodic nature of the medium that fosters critical thinking through a non-trivial type of reading. Within this context, the term *ergodic* refers to the use of cybertext's extranoematic performance, which, according to Espen Aarseth, "focuses on the mechanical organization of the text, by positing the intricacies of the medium as an integral part of the literary exchange" (*Cybertext* 1).

Another type of interaction emerges from the exchange of ideas among students and scholars through hypermedia. By receiving feedback from people from distant places, students and scholars become aware of intercultural differences. This representation of a variety of multicultural perspectives and differences is nowadays a "de facto consequence" (Kommers 22).

Hypermedia systems do not efface multicultural differences; on the contrary, they create a space where ideas coming from different backgrounds coexist and struggle to achieve a common purpose, which is the enlightenment of the human being. This concept is even more alive today via a myriad of literary Web logs. According to Jill Walker, a *Weblog*—or what is commonly called a *blog*—is "a frequently updated Web site consisting of dated entries arranged in reverse chronological order so the most recent post appears first" (*Routledge Encyclopedia of Narrative Theory* 45). Readers of these literary sites join participants from all over the world and exchange ideas via threaded postings where they can express their different perspectives on specific issues related to that blog.[11]

Non-sequentiality is another outstanding feature of hypermedia. Unlike most print media, hypermedia allows users to move back and forth as they create their own paths and establish new associations. Ted Nelson's vision of hypertext is grounded on two main premises. On the one hand, Nelson relies on "that which simply connects chunks of text by alternative choices" (*Literary Machines* 1/15). This type of presentation of material whereby the reader moves from one lexia to another he calls "chunk style hypertext." The other form suggested by Nelson where materials are viewed and combined with others is labeled "compound text" (1/15). Ted Nelson argues "[t]here are two outstanding reasons for breaking away from sequential presentation" (1/15). In his opinion, sequential presentation "spoils the unity and structure of interconnection" (1/14), and "it forces a single sequence for all readers which may be appropriate for none" (1/14). Nelson acknowledges that even though certain books provide multiple readings, computers are more adequate tools to assist in traversing dispersed fragments of text. Nelson's claim is based on his assumption that "it would be greatly preferable if computers could create different pathways for different readers, based upon background taste and understanding" (1/15). These options, which ultimately depend on those in charge of developing new operating systems and software, would "give readers many choices in approaching the same work" (1/15). In spite of all the possibilities for critical thinking and technological innovations that the electronic hypertext promises to offer, it is fair to highlight that some of its most outstanding features can be traced back to an oral tradition that relied on the process of association and memorization.

## From Oral Literacy to Borges's Textual Universe

The idea behind hypertext is not new. It existed in the oral tradition as well as in medieval times. If we want to establish a connection between hypertext and the past, we have to refer to the hypertextual qualities present in oral and

written communication before the advent of the electronic hypertext. According to Eric Alfred Havelock in his book *The Muse Learns to Write,* the "orality problem, as it has been presented itself for investigation during the last twenty-five years, has been argued from several points of view" (24). He states that the contemporary issue is "the relationship between the spoken word of today (or yesterday) and the written text" (24). He also points out that, from a philosophical or psychological point of view, the question is whether oral communication is the instrument of an oral state of mind or a type of consciousness quite different from the literate state of mind (24). These are the two issues that I will discuss in order to illustrate the narrow gap between oral communication and hypertext.

In order to examine the relationship between the spoken word and hypertext, one must start by looking at the characteristics of oral literature before Homer's day. Many researchers have seen that period as one of illiteracy. I would prefer to use the term *non-literacy,* because the main features of oral literacy were different from those established by the written word. The period of oral literacy had its own codes that enabled the creation of quite advanced societies without having to depend on the existence of the written word, as illustrated by the civilization of the Incas of Perú. The Incas' social organization and technological advances demonstrate that they were not illiterate but rather non-literate, because they did not use the written word as means of communicating ideas or feelings. As an alternative to writing, the Incas used a system of knots in ropes called *quipu,* a system that facilitated communication and contributed to the organization and trading in the Inca empire.

Before Homer's day, oral communication relied on rhythm to promote effective memorization. This process was a key element in preserving the rules and tradition of Greek society. Through a process of association of ideas, reciters, minstrels, and ordinary people were able to transmit information. Oral communication fulfilled an entertaining as well as a didactic function in Greek society. The advent of the Greek alphabet did not all of a sudden replace the acoustic means of communication—they coexisted for a long time. Thus, the written text inherited the musicality of oral communication. Havelock writes that "Platonism, being a written text, was unable to formulate a new conceptual type of language and of thinking as a replacement for oral narrative and real thinking" (qtd. in Havelock, *The Muse Learns to Write* 29).[12] In spite of these changes in modes of communication, the written word could never fully translate what was really meant by its oral counterpart. Whereas the alphabet provided the possibilities of transcribing

anything framed and spoken, the power of orality survived through the so-called written literature of high classic Greek (Havelock, *Muse* 92).

Another important feature of oral literacy is its power as a medium for communication, generally between an individual and an audience. By establishing links between addresser and addressee, oral language fulfills its collectivist purpose, which is based on a shared code. The possibilities offered by oral literacy did not seem to suffice for the Greek society that, in order to secure tradition, invented the Greek alphabet. Through writing, the Greeks could visualize and recall what had been spoken. The Greeks invented the pure consonant, which "supplied our species with a visual representation of linguistic noise that was both economical and exhaustible" (Havelock, *Muse* 60). This system allowed the text to truly speak a language of preserved communication, a body of useful "oral information," and at the same time to store information in a more efficient way that had been done before. According to Havelock, at that time there was a "transformational change" allowing the "singing muse to translate herself into a writer" (62). In his opinion, the alphabet was created under the aegis of the singing Muse when her song was still supreme (62).

Whether we speak of oral literacy or hypertext, we are still dealing with language. The issue that brings them together is the performatory function of language: one person addresses another. Language allows for interpersonal relations just as the electronic medium allows one to overcome the intermediate barriers of the family or town to reach long distances and create what have been called "electronic communities." Hypertext embodies the oral tradition through Havelock's definition of interpersonal communication: "The genius of the unrehearsed conventional language lies in its expressiveness; its capacity to voice immediate sensations and impressions and feelings as between individuals, and also social modes and fashion and ideas as they are felt in the community. It is astonishingly flexible and mobile, and it always has been. That is what talk is" (*Muse* 64).

There is yet another aspect of the oral tradition that echoes in hypertext. Having in mind that action is a key element in the process of communication, I suggest that by allowing the reader to exert her own choices over a text, hypertext supports interaction between addresser and addressee. In the same way that oral communication entails action from the addresser to voice her sensations and impressions, hypertext demands reflection and action from the reader to create a text. Whereas oral communication allows for a dialogical exchange, creative hypertexts also allow for the addition of comments to the text, thus creating visual interaction between the text and the reader.[13] The latter feature is not unique to the electronic hypertext because, as

evidence has shown even in the first Egyptian dynasty (c. 2925–c. 2775 BC), "images of persons were also annotated with their names or titles, a further step toward expressing individuality and uniqueness" (*Encyclopædia Britannica*). The unique aspect of hypertext is its ability to incorporate comments into the text so that they become an integral part of the text, which can be visualized only as needed. In contrast to the fixity of the print medium, the mobility and flexibility of oral literacy can be compared to the dynamism and instability of the electronic text. Any step taken in a docuverse calls for a rethinking of the whole text as the reader tries to establish some type of relationship between lexias. Each node indicates a momentary position towards an attempt to grasp some understanding of the situation.

This concept resonates in Havelock's definition of communication as "a process of spontaneous exchange, varied, flexible, expressive and momentary" (*Muse* 64). This definition seems to almost overlap with David Bolter's definition of electronic writing, which he labels as "fluid and dynamic" (4). In my opinion, the process of creating and reading a hypertext is intimately related to the dynamism and flexibility of the human mind. The fact that hypertext imitates the mental process of association relates it even further to oral literacy. Within a hypertextual environment, association is always present in any text: one word echoes another word; one sentence or paragraph repeats a previous link in the text as a flashback effect and yet anticipates linking to others.

Another key feature in oral literacy as well as in hypertext is memory. For the oral legacy to survive in non-literate cultures, people had to use memory to transmit what had been told to them. According to Havelock, "recall and recollection pose the key to our civilized existence" (*Muse* 70). In the past, ritualization guaranteed the survival of language. As time went by, writing supplied us with an artificial memory that turned the flexible spoken words into a fixed state. Within this framework, it is not far fetched to see hypertext as a metaphor for the process of memorization and as a visual representation of the way the human mind operates, because hypertext allows readers to recall information, to make links between lexias, to save those connections for future reference, and to write down personal comments.[14] On many occasions, the lexias presented to the reader help not only to establish some contrast or similarity but also to trigger innovative ideas. Thus hypertext can be seen as a better environment to materialize some of the features of the spoken word because it does not contrive speech as much as printing does.

Havelock affirms that the language of oral literacy had not only rhythm but also a narrative structure to assist memorization (75). Reflection and

action were emphasized through language. Similarly, it is through the actual connections that hypertext allows the reader to make, that the new technology resembles oral literacy. Nevertheless, there are examples when the narrative, though very well structured at the programming level, resembles a chaotic reading environment. In such circumstances, the hyperfiction reader engages in the intellectually demanding process of trying to understand what might seem as absolute chaos or nonsense. The challenge of the new medium forces the reader to go beyond the plot and to take a more critical stance towards literature. Once the text comes into being through the intellectual and physical engagement of the reader in the ergodic process, the structure of the text is scrutinized and becomes one more important element to be taken into consideration. The reader gets a better understanding of a text through her actual interaction with a text. The text can be preserved in the machine's memory for further reference, but above all it is the activity that goes on between the text and the reader that fosters the process of critical thinking and memorization.

According to Havelock, in oral poetry narrative takes the form of parataxis: "the language is additive, as image is connected to image by 'and' rather than subordinated in some thoughtful relationship" (*Muse* 76). This feature, which creates a flow of sounds and images, can be compared to the web-like structure created through hypertext. In a hypertext environment, the language within it is constantly undergoing change, a process of becoming. In a similar fashion, the reader of a docuverse document can move from one screen to another at ease, thus thinking about the connections between one lexia and another, because each lexia contributes to the understanding of the text. The reader participates in the reading process in a fashion similar to the way an oral society engages in oral poetry and in an active dialogue among its members.

As we have seen so far, there are similarities between the oral tradition and the qualities of hypermedia. The similarities between preprint and postprint communication provide a space to introduce the attempts of some of the printed works to overcome the rigorous authority of its medium. Within this group of writers is Jorge Luis Borges, who through his superb use of language manages to exceed the limits of print. Thus, examining the qualities of hypermedia and how it functions helps us to understand the process of understanding preprint, print, and postprint literature from a new perspective.

### Jorge Luis Borges's Ideas about the Reader and the Writer

Borges's ideas concerning the active participation of the reader in the process of literary understanding moved him to write texts whose own creation and existence would depend on the reader's ability to accomplish her reading tasks. Reader and reading are two key elements in Borges's intellectual universe. Thus, influenced by these strong ideas and his metaphysical quest, he developed a network of literary texts that exceed the limits of print and challenge the mind. Borges's futuristic ideas about alternate and simultaneous worlds influenced his unique narrative techniques, giving way to "The Garden of Forking Paths," which defies sequence and overflows the static line of the book. This metaphysical quest, together with the intertextuality and the intratextuality present in Borges's texts, opens up the way to a hypertextual study of Borges's fiction. All these features are supplemented by a sense of openness in Borges's stories, which resembles Eco's definition of the *open work* and which will be dealt with in Chapter 2 of this book.

In order to comprehend Borges's writing through the lenses of hypermedia, it is crucial to exfoliate Borges's ideas about the roles of the author, the reader, and the text. From a Borgesian perspective, the relations between author, reader, and writer resemble some of the tenets proposed by postmodern critics.[15] Throughout Borges's texts, the author almost vanishes and the authorial function moves into a shadow to foster the emergence of an active reader, who in turn is given the possibility of re-creating or re-inventing a text. Borges accentuates the act of reading throughout his writing. Like the phoenix that emerges from the ashes and creates itself anew, the reader of Borges is confronted with "that imminence of a revelation as yet unproduced" that can only emerge alongside the interaction between reader and text.[16] As meaning in a Borgesian text does not appear on the surface but within an intricate fabric created through language, each reading act is a new birth or recreation of a text. Through the act of reading, the reader becomes a crusader in a desperate attempt to disclose the hidden signification of discourse and/or its structure. It is the constant search for meaning, the quest for a revelation, that moves a reader along in a Borgesian text. As the reader cannot take for granted the sometimes nonsensical and idealistic portrayal of the world embedded in Borges's texts, she is compelled to create meaning out of what seems absolutely illogical or unreliable. Many of Borges's stories are metaphors for alternate worlds or ideas, as in the case of "The Garden of Forking Paths." The inescapable presence of hidden elements, subtle intratextual or intertextual references, or codes to decipher in a Borgesian text forces the reader to pave her way through the text to unveil its meaning. Thus, this kind of reading act kind shares with hypertext its ergodic

nature. A high degree of intellectual effort is needed to traverse the text. The relevance of the reading act is accentuated not only through the examination of what is already there and visible, but also through a process that encourages the reader to ponder what is absently present.

In his article "La Littérature selon Borges," Gérard Genette unravels Borgesian aesthetics:

> The genesis of a work in the time of history and the life of an author is the most contingent and most insignificant moment of its duration....The time of a book is not the limited time of its writing, but the limitless time of reading and memory. The meaning of books is in front of them and not behind them; it is in us: a book is not a ready made meaning, a revelation we have to suffer, it is a reservation of forms that are awaiting to have some meaning, "it is the imminence of a revelation that is not yet produced," and that everyone of us has to produce for himself. (qtd. in Emir Rodriguez Monegal, *Prose for Borges* 105)

A self-effacing writer, Borges considers himself a reader who values the intellectuality of the reading act. From his perspective, none of his work is original or innovative; he is just the discoverer of someone else's lines. It is through his writings that he turns into a mere translator or editor of someone else's work. From this perspective, and according to Sylvia Molloy in her book *Signs of Borges*, "the act of writing and the act of reading may seem (and possibly are) tautological acts" because each reading implies a rewriting of the text (32). Borges's humble and ironic position is expressed in the preface to the first edition of *A Universal History of Infamy*, where he emphasizes his position as a reader and not as an author of certain texts:

> As for the examples of magic that close the volume, I have no other rights to them than those of translator or reader. Sometimes I suspect that good readers are even blacker and rarer swans than good writers. Will anyone deny that the pieces attributed to Valery to his pluperfect Edmont Teste are, on the whole, less admirable than those of Testes' wife and friends? Reading, obviously, is an activity which comes after that of writing; it is more modest; more unobtrusive, more intellectual. (*A Universal History of Infamy* 13)

By the same token, Borges acknowledges the intellectuality of the reading act, and his position that reading comes after, not before, writing. Borges's claim is almost the reverse of what actually took place throughout his career. Borges, an avid and polyglot reader, used his diverse readings and life experience as an eclectic source of information for his writings. Even though reading and writing were part of Borges's life at an early age, his readings

and translations of some of the classics of literature stimulated his almost limitless imagination.

Borges creates disquieting moments for the reader. His provocative writings challenge the reader's imagination in an attempt to exhaust the linguistic sign, which is constantly shifting and admits no fixed relationship between signifier and signified. Borges calls into question the relationship between imagination and reality, the logical and the nonsensical, and the reading and writing process. Thus, in order to recreate Borges's fiction, the reader must become aware of the subtleties and metaphysical ideas embedded in a Borgesian text. Only then will the reader be able to pave her way through the text and create a new writing through her own reading.

Throughout his texts, Borges manifests the supremacy of reading and disguises the importance of writing. His aesthetics is "based not on the creation of the literary work but on its reading—instead of aesthetics of the work of art, an aesthetics of its reading" (105). This new aesthetic stems from Borges's style, which moves the reader to create almost simultaneous worlds within the limitations that are imposed by writing but overcome by language and thinking. Reading Borges entails becoming familiar with his language and the fantastic worlds he creates through language. He provides parts and threads and leaves up to the reader the task of creating order out of what might look like an incomprehensible thread of ideas. Like James Joyce and Virginia Woolf, Borges is interested in the thinking process, but his unique style and use of language force the reader to rethink controversial issues such as authorship and writing and reading as tautological events.

By undermining the role of the author, Borges presents to the literary world two ideas that supplement each other: (1) the author vanishes from the literary act; and (2) the reader moves into the text through the space left open by the author. These tenets relate to the ideas expressed by Roland Barthes in his essay "The Death of the Author." Borges, like Barthes, subverts the notion of the author. Both make almost the same claim. The figure of the writer disappears as soon as writing takes place and paves the way to reading. Language takes over and supersedes the power of the author. Through language, the reader can hear the voice of a text that is potentially rich in meaning. In reference to the originality of an author's work, Barthes claims that "the writer can only imitate an even anterior, never original gesture" (1132). Thus these two *littérateurs* present the relations between author, reader, and text from a new perspective, since they have anticipated a discussion that emerged in the late eighties as a result of the development of electronic hypertexts. Since the emergence of hypertext, new roles have been assigned to the author, the reader, and the text. Whereas Barthes's perspec-

tive presents the critical background to understand Borges's ideas, the Borgesian texts per se provide us with a more tangible representation of the ideas stemming from the new electronic age. Many of Borges's fictions reflect features that look clearly hypertextual if examined from a technological perspective. Among the most prominent hypertextual qualities within Borges's texts are intertextuality, the idea of polyvocality or heteroglossia, non-linearity, the relevant role assigned to the reader, and the provocative invitation to the reader to collaborate in the recreation of the text. These stylistic similarities with hypertext as well as the innovative thematic of his work make Borges a forerunner of the new technologies and invite his readership to interact with texts from an ever-evolving perspective that takes into account historically relevant scientific and technological developments such as chaos theory and the advent of hypermedia systems, including the fast growing genre of video games.

# Notes

1   At the 2002 Symposium at UCLA, the ELO agreed on the need to fund projects that will allow the preservation of digital works. For a list of projects mentioned at the meeting, see http://www.eliterature.org/programs/pad/.

2   Project Xanadu is an ongoing project started in 1960 by Ted Nelson. Its method is based on the premise that "all media contents get permanent addresses, so that they can be addressed by anyone independent of their documentary context. Online quotation references these permanent addresses. All links reference these permanent addresses, so that the same links are always on the same content." For a detailed and updated description of the project refer to http://www.xanadu.net.

3   Joyce, "What I Really Wanted to Do I Thought" in *Of Two Minds* 32.

4   For a thorough explanation on "forking paths" see Moulthrop "An Anatomy of 'forking paths.'"

5   For a detailed description of Brown University course English 73, formerly Context 61, see http://www.victorianweb.org/courses/61syllabus.html.

6   For the latest update on the Victorian Web see http://www.victorianweb.org.

7   Perseus was first created with a HyperCard authoring system, and later on it evolved into a CD-ROM and a large non-profit digital library project hosted by the Department of Classics at Tufts University. For the latest version of the Perseus project, see http://www.perseus.tufts.edu.

8   Many scholars have described the reading process of a hypertext and its structure in a similar fashion. See Landow and Delany, *Hypertext, Hypermedia and Literary Studies: The State of the Art* 3.

9   In his famous essay "Language to Infinity."

10   The Victorian Web is a clear example of a hypermedia environment that can be used for understanding literature from a new perspective. The various links to literary theory, history, social studies, science, and technology provides a multidisciplinary approach to the study of literature.

11   For the thorough explanation of the term *blog,* see Jill Walker's definition in the *Routledge Encyclopedia of Narrative Theory* 45.

12   In this quotation, Havelock refers to his comments on Chapters 11–15 of his previous work, *Preface to Plato.*

13   Whereas exploratory hypertexts allow only a reader function, creative hypertexts allow the reader to add notes to the existing digital document.

14   These are some of the features embedded in Moulthrop's *Victory Garden.*

15   Postmodern criticism as well as hypertext emerged from the discontent with the authoritative and hierarchical ideas shaped after the invention of the printing press. Thus, postmodern critics such as Derrida, Barthes, and Kristeva provide the theoretical background to understand issues that are materialized in hypertext. Concern with displacement, the new role of the reader and the text, non-linearity, and intertextuality are some of the concepts shared by postmodern criticism and hypertext. For a better

understanding of this topic see Landow, "What's a Critic To Do? Critical Theory in the Age of Hypertext" in *Hyper/Text/Theory* 1–47.

[16]   Phrase used by Jorge Luis Borges in "The Wall and the Books" 346.

# Chapter 2

# Jorge Luis Borges: A Forerunner of the Technology of the New Millennium—Links and Forking Paths

No hypertextual product can realize the "strictly infinite labyrinth" of Borges' fantasy.

Stuart Moulthrop, "Reading from the Map: Metonymy and Metaphor in the Fiction of Forking Paths"

The concept of *hypertext,* a term coined in the last fifty years, was envisioned by several writers before the advent of the electronic hypertext. Julio Cortázar's *Hopscotch* and Jorge Luis Borges's "An Examination of the Work of Herbert Quain" and "The Garden of Forking Paths" are frequently referred to as forerunners in the realm of hyperfiction. At the beginning of *Hopscotch,* Cortázar states that his work can be read in two ways. The first method follows a traditional linear reading, from the first page of the novel to the last, whereas the second method uses an alternative ordering of the chapters suggested by the author. Borges's texts overflow the limits of print by allowing readers to envision the possibility of multiple worlds and endings in their own minds. It is the enigmatic game between the mind and the power of language that sets the foundations for Borges's metaphorical stories and their embedded hypertextual features.

Many philosophies, styles, and approaches to the understanding of literature have emerged since the appearance in 1987 of the first hyperfiction, *afternoon, a story,* by Michael Joyce. This new approach to literature is known as *hypertheory.* It is not a canon, and as in literary theory, there are many positions to be adopted. Therefore, this chapter focuses on studying the perspective of a small number of leading hyperfiction theorists and writers such as Michael Joyce, Stuart Moulthrop, and Yellowlees Douglas as well as the theoretical stand on language presented by Michel Foucault in his essay "Language to Infinity." This selection has been grounded on the pioneering work done by these hyperfiction writers as well as on the relevance of Foucault's work to the understanding of Borges's "The Garden of Forking Paths."

Michael Joyce's pioneering hyperfiction, *afternoon, a story,* set a landmark in literary studies and literary criticism as the first hypertext novel ever published. By the same token, Stuart Moulthop's hyperfictions and scholarly

work have demonstrated how Borges's works relate so well to hyperfiction and cybertexts. This idea has been extensively developed in Moulthrop's "forking paths," in his hyperfiction *Victory Garden,* and in his cybertext "Reagan Library." Within this framework, there is no doubt that Moultrop's pilot hypertext "forking paths," which was used by Yellowlees Douglas and her students at New York University as an experimental exploration of hypertext and its value in literary studies, provides a suitable starting point for the discussion of Borges's "The Garden of Forking Paths" and hypertext.

In his book *Writing Space: The Computer, Hypertext and the History of Writing,* Jay David Bolter states that Borges's "'An Examination of the Work of Herbert Quain' is the literary obituary of a writer who tried to liberate his texts from linear reading and static interpretation" (138). According to Bolter, "Quain's novel *April March* is nothing less than an interactive fiction" (138). Similar assumptions concerning the hypertextual features present in Borges's text have been made by Moulthrop in his article "Metonymy and Metaphor in the Fiction of Forking Paths" and by Ema Lapidot in her article "Borges: Between the Printing Press and the Hypertext." Still, Borges's texts exceed the limits of print in a different way than hypertext does; their intellectual appeal lies not on the visual connection that the mind makes but in the more expansive possibilities of creating new and fictitious worlds in readers' minds. There are similarities and differences between some of the features embedded in the short stories by Borges and their digital approximations; this section will look specifically at the differences between the *forking paths* proposed by Borges in "The Garden of Forking Paths" and the links present in hyperfiction.

"The Garden of Forking Paths" was published in 1941 in a collection of literary works that bears the same name as the short story in question and is one of Borges's works most frequently cited in reference to hypertext. The story per se can be classified as a typical detective story, with a number of subtle clues left along the way in order to lead the reader to the desired resolution embedded in any detective task. The story takes place in Europe during the First World War, and the protagonist turns to cruel, war-like techniques in order to accomplish his objectives in a time of violence and confusion. Yu Tsun, a former English teacher, risks his life in order to send a message across the ocean, a voice that can be heard through someone else's death. Yu Tsun becomes a German spy, not for the sake of Germany but in order to raise the esteem of his race in the eyes of the Germans. He has to kill the learned Sinologist Stephen Albert in order to provide to his chief the name of the city where the British artillery is located. While trying to accomplish his mission, Yu Tsun engages in an enlightening conversation

with Albert, who tells him about his life research on the work of Ts'ui Pên, his novel and his labyrinth. Albert has discovered that Ts'ui Pên's novel and the labyrinth are the same and that the chaotic novel entitled "The Garden of Forking Paths" is "a picture, incomplete yet not false, of the universe as Ts'ui Pên conceived it" ("The Garden of Forking Paths" 101).

Borges's title is a metaphor for alternate worlds or ideas, as suggested by the words *forking paths*. This phrase is essential to the work from which it emerges and has a unique meaning within the medium it was created. Through language, Borges's *forking paths* create the possibility for imagining alternative worlds, whereas electronic links allow the reader to move from one node or *lexia*—as Roland Barthes terms it—to another, allowing the reader to create her own path. How does a *forking path* differ from a link? I will carry out such exploration having in mind the main features of links in interactive fiction as well as Borges's interest in the imaginative process and the overwhelming power of language.

### Hyperfiction and the Nature of Links

Hyperfiction, the type of fiction that is created to be read on the computer screen, is a relatively new genre. The invention of the genre is attributed to hypertext writer and developer Michael Joyce, who, in 1987, produced *afternoon* one of the first examples of hyperfiction. In Bolter's words, "[w]hile a printed novel presents its episodes in one order; the electronic writing space removes that restriction for fiction as it does for the essay. Instead of a single string of paragraphs the author lays out a textual space within which his or her fiction operates" (122). In order to move through the text and interact with it, the reader needs to activate links, which in turn will determine the reader's next step or course of action. Thus, links constitute a crucial element in the creation of a hypertext fiction since their selection undoubtedly affects the reading process. In Joyce's *afternoon,* text and links represent the key elements of his hyperfiction. The relevance of links and their significance in the reading process has also been highlighted by John Slatin, who, taking into account Douglas Hofstadter's claim that perception of relatedness is a defining characteristic—perhaps *the* defining characteristic—of intelligent behavior, states:

> Hypertext embodies this idea, for everything in hypertext depends upon linkage, upon connectivity between and among the various elements in the system. Linkage, in hypertext, plays a role corresponding to that of sequence in conventional text. A hypertext link is the electronic representation of a perceived relationship between two pieces of material, which become nodes once the relationship has been instantiated electronically. That is, the link simulates the connections in the mind of the

author or reader; and it is precisely because the electronic link is only a simulation
that problems will arise. (877)

Links, or "decision points" as Joyce and Bolter call them, are created with a
rationale in mind, but in all cases the links have been limited by the possibili-
ties of the authoring program used to create the literary piece. From this
perspective, the links in hyperfiction lead to a limited number of multiple
pathways, thus making possible a number of different stories. Given that
links exist only within a system, let us examine how a system for interactive
fiction works and how links function within such a system.

Let us refer to StorySpace, a system for interactive fiction created by
John Smith, Jay Bolter, and Michael Joyce in 1981. This system allows two
modes: a reader mode and an authorial mode. Whereas the reader mode
permits the navigation along an invisible circumscribed number of paths, the
authorial mode allows the author to actually see and edit her textual episodes
by means of a structural editor. It follows that the author has access to a
graphic or diagrammatic view of the hypertext she is creating, whereas the
reader's view has been already limited by the system. Within such a frame-
work, it is easier for the author than for the reader to see the connections
between the nodes or lexias because the former has access to the overall
picture, whereas the latter can only see the lexia into which she has just
moved. The reader's search for meaning is the driving motive of her quest. It
is up to the author, who in most instances is the developer, to set the limits or
freedom of her hyperfiction because she can provide the reader with an
authorial capability that makes visible the graphically established connec-
tions. By the same token, it is the programmer who can allow the reader to
add lexias to the existing nodes of the text.

Hyperfiction authors feel compelled to imagine the type of links that the
reader might make; in doing so, however, authors also limit the possibilities
of hypertext. According to John Slatin, the approach one chooses to the
problem of identifying links and nodes will depend on several factors, such
as one's understanding of the ways the material is organized and one's sense
of who one's readers are (879). Taking into consideration the reader's roles
and the flexibility of the authoring system, Slatin refers to three types of
readers: browsers, users, and co-authors (875). Thus, in Slatin's words,
"browsers tend to read for pleasure" and "there is no expectation that the
browser will go through all of the available material," whereas the user is a
"reader with a clear—and often limited—purpose" (875). In the case of
hyperfiction, readers are likely to be browsers, users, and co-authors, as in
the case of those hyperfictions that allow readers to add new lexias to the
story.

Hyperfiction readers try to reach the point where they can derive meaning from the story. This idea is not related to the canonical idea of beginning, development, and ending. Hyperfiction readers look for that point in the narrative that helps satisfy their curiosity and to a certain extent achieve their own objective of finding some kind of personal closure in the story or stories present in the text. Users, on the other hand, are readers with a clear purpose in mind who engage in the co-authoring stage, adding new lexias to the existing ones, if the system allows them to do so. These new lexias can take different forms, such as comments on the existing nodes, or additions to the existing document. At present, commercial interactive fiction takes the mode of read-only text, though there have been collaborative online hyperfiction projects such as Hypertext Hotel Moo and *M is for Nottingham* that allow the addition of nodes by different users.[1]

Throughout the short history of hypertext, there have also been developments in the classification of links. During the early stages of hypertext, researchers focused on semantic or functional links, whereas in the mid-nineties, "links [began] to be thought about in terms of their theoretical implications, thus expanding and complicating the capabilities of links" (Strasma 3). In his article "Hypertext: An Introduction and Survey," Jeff Conklin distinguishes three major types of links: referential, organizational, and keyword (qtd. in Strasma 4). In all instances, links are there to guide the reader to create meaning from the text. Not all hyperfiction readers have welcomed this interpretation of the link, particularly those who have reviewed hyperfiction without understanding its rhetoric. On many occasions, it has been said that hyperfiction is nothing more than a sum of links, adding confusion to the reading process. According to Moulthrop, "links may mean more than they appear to do on a simply technical level. Instead of focusing entirely on instantaneous replacement we might think of links as having two components: the visible binary circuit of connection (technology's fort/da) and the unseen matrix or 'structure of possible structures' against which this transaction is realized, figure against round" ("Pushing Back"). Such an interpretation of links permits one to envision other paths besides those selected by the reader. The link activates one of the text's multiple possibilities. The actual clicking on the link brings to the surface and thus materializes—to a certain extent—one of the paths delineated by the author. Hence, links in hyperfiction act as catalyst elements in the study of narratives. By bringing to the surface one of the text's various possibilities, links create a space for discussing narrative and the act of reading.

**From *afternoon* to "The Garden of Forking Paths"**

In order to comprehend the relevance of links to hypertext, especially in terms of Borges's works, I will start by referring to Michael Joyce's *afternoon,* one of the first examples of hyperfiction. This new genre, which shares many of the characteristics of the adventure games, provides the reader with text as well as links so that the reader can produce a number of different readings. From this perspective, *afternoon* is not so much about a story or stories but about the creation of different readings: "All the text of the episodes was written by Michael Joyce, but the particular order in which the episodes are visited is determined at the time of reading" (Bolter 123). Each time the reader engages in the intellectual task of moving along the parts set by the author, she is challenged to make her own decisions. Ultimately, it is the reader's choices that determine the outcome of the story. As the reader progresses through the lexias that resemble the conventional space of the printed book, she is also offered the possibility to take the unconventional routes of "words that yield."[2] These choices will determine whether the reader moves chronologically into the story or instead sees on the screen a series of flashbacks in the story. There still exists the default option for those who are uncertain of taking control over the creation of a new reading. Even though this last option might sound less challenging than the selection of a link, its outcome is still charged with unpredictable turning points

All the readings shaped by the hyperfiction reader of *afternoon* do have characters and events in common. They all share the presence of Peter the poet, Wert the owner of a software company, Wert's wife, and Wert's employee, Naussica. Even though their roles are clearly determined, the type of relationship that grows among the characters through the reading depends on the choices made by the reader. Certain events stand out more than others. According to Bolter, "one of the most gravitationally powerful events is common place: Peter has lunch with his employer. What makes the event important is that it is a structural crossroad: the intersection of many narrative paths" (125).

From beginning to end, the hyperfiction reader needs to be physically and intellectually engaged in the reading process. There are no readings unless there are actions taken by the reader. Bolter writes that "[m]any different responses will cause the text to move, but until the reader responds with some action of the keyboard or the mouse, the text of an episode remains on the screen, conventional prose (occasionally poetry) to be read in the conventional way" (124). As in computerized adventure games, the

actions taken by the reader are an attempt to explore and to make sense of the various levels that the story contains. More often than not, the reader finds herself struggling with the ever-changing structure of the reading with which she is trying to come to terms. The struggle for meaning is enacted by the characters in *afternoon,* a procedure that is by now a conventional theme of twentieth-century literature. The novelty here is that reader plays out the allegory as she reads the story, as Bolter explains: "'Afternoon' becomes the reader's story in this remarkable way. Readers experience the story as they read: their action in calling forth, their desire to make the story happen and to make sense of what happens, are inevitably reflected in the story itself" (126).

Borges's "The Garden of Forking Paths," on the other hand, is an allegory of multiple times, as will be elaborated later in this work. There is a story or a number of stories within it, but what Borges attempts to accomplish moves beyond the plot and must be inferred by its readers. By the same token, Joyce's *afternoon* is not so much about its plot as about its own reading and the reading of hyperfiction; in bringing forward this issue on the screen or in virtual world, the story materializes the problem. Borges, on the other hand, presents the metaphor and invites the reader to visualize the idea of alternate worlds in her mind.

## Forks to Infinity

Borges's story "The Garden of Forking Paths" invokes a complex relationship between temporality and language. This issue is presented to the reader through the metaphor of *forking paths* which attempts to create a mental representation of the problem. According to the *Oxford English Dictionary,* the word *fork* is a dichotomy, dilemma, a choice of alternatives, or a dichotomy and distinction. The *Oxford English Dictionary* defines the adjective "forked" as "[m]aking a fork; having two or more diverging branches." Both definitions help the reader understand Borges's attempt to illustrate his belief in the power of language as well as his ideas concerning the possibility of alternate simultaneous worlds. The word "forking" gives to Borges's title a more active connotation than the adjective "forked," thus highlighting the idea of forks and paths that multiply and propagate infinitely.

In his story, Borges offers the reader a choice of path, a choice whereby the reader will determine the fate of the characters. According to Moulthrop, "[i]f we read "The Garden of Forking Paths" not as a novel of Ts'ui Pên or the labyrinth of Jorge Luis Borges, but as the story of Yu Tsun and Stephen Albert, we must confront a dire reductiveness" ("Reading from the Map" 121). These limited possibilities arise from the limitations of print as well as

from the conventions of the detective story per se. If the reader explores "The Garden of Forking Paths" as the plot of a detective story, she will face the need for closure and resolution. On the other hand, if the reader discovers Borges's metaphysical ideas, such as the possibility of multiple times, she might be willing to engage in the search of the multiple plots hinted by the author throughout the text. Borges's story is not a conventional detective story; it presents a puzzle to a solution instead of a resolved crime.

Moulthrop's claim is that that there are two plots and that the plot of enlightenment "intersects disastrously with a plot of espionage" ("Reading from the Map" 121). Whereas the first plot refers to Yu Tsun and his discovery of his ancestor's theory of time, the second plot is a mere detective story. In this fashion, "The Garden of Forking Paths" initiates a critique of narrative closure. On one level, "The Garden of Forking Paths" is a narrative containing the definite closure required by the detective story, whereas at another level, Borges strengthens the power of language and undermines the canon established by print. Language succeeds in breaking the boundaries of the static line to give way to multiple stories. In reference to the concept of multiplicity, Moulthrop states that "Yu's hallucination of multiform, invisible persons has a double valence. It discards as unreal the alternate outcome that the present narrative cannot provide, but at the same time it gestures towards a realm of experience greater than that contained in a specific story" ("Reading from the Map" 122).

"In a hypertextual version of "The Garden of Forking Paths," Yu Tsun's vision of alternate selves would be no illusion, at least from a readerly point of view. The "future" or (ending) in which Yu sacrifices friendship to duty could be avoided; the reader could select a different way through the garden of forking paths" (Moulthrop, "Reading from the Map" 123). Borges makes the reader aware of other possibilities via the words of one of his characters, Albert. Albert explains to Yu Tsun that on this opportunity he, Yu Tsun, has come to him, while in another situation Albert could say the same words but he, Albert, will be "an error phantom" ("The Garden of Forking Paths" 100). This paragraph foreshadows Albert's death, a death that helps to bring closure to the story.

There are two main reasons why "The Garden of Forking Paths" tries to bring closure to the reader. On the one hand, it is a detective story and as such it needs and has a resolution brought by Yu Tsun when he kills Albert to give away the location of the British artillery site. On the other hand, this story has been written in a printed medium that limits the visible and actual branching of the story into different paths. With these ideas in mind, "The Garden of Forking Paths" resembles an exploratory hypertext, an electronic

space where the reader is given a limited number of choices. The reader cannot add any lexia. She can only traverse the territory that has been given to him or her.

On the other hand, it is possible to look at "The Garden of Forking Paths" from another Borgesian perspective that underscores the role of the reader and the power of language. "The Garden of Forking Paths" allows language to activate one of its strongest qualities: the ability to extend to infinity. It is through language that Borges's story presents a puzzle to a solution. Borges does not provide a unique answer to his story; on the contrary, he challenges print through language provoking the reader to solve that what has been laid out in front of him. His text is in excess to any solution because it relies heavily on the reader's intellectual skills and the power of language. In "The Garden of Forking Paths," Borges provides hints that could help the reader to create a new thread in the story. This technique resembles the possibilities offered by creative hypertexts where the reader can actually write an ending to the story. Through the reader's process of creating an imaginative ending to the story, the text manages to overflow the boundaries of print. It is the reader's engagement in the thinking process that allows for the creation of a new literary text. This idea takes us back to Borges's aesthetics of reading as well as to Genette's idea that "a book is a reservation of forms" awaiting to disclose some meaning that each of us has to find by himself (qtd. in Monegal 105). Viewed from this perspective, Borges's *forking paths* reach outside the limits of print and move towards infinity. This fictitious movement can only materialize itself in the reader's mind.

In modern hypermedia environments, hypertext allows excess by virtue of the "program" and language; Borges's "The Garden of Forking Paths" allows excess *only* by virtue of language. Though there exists a degree of parallelism between the two, Borges's fiction supersedes any limitation and constraint. His texts impersonate the power of language to infinity. Hypertexts, on the other hand, trigger an infinite number of associations and ideas through their links and the possibility they have to allow the reader to actually provide a virtual ending to a story. In spite of this capability, most hyperfictions have been examples of exploratory hypertexts where the reader is encouraged to find her way out a hyperfictional maze. Most commercial hyperfictions are created with authoring programs that do not activate the constructive feature latent in hypertext. Authors work hand in hand with programmers, developers, graphic designers, and media specialists in order to optimize the possibilities of hypertext.

In spite of the myriad of possibilities for presentation that hypertext offers, there are those who believe that the possibilities for developing hypertext interfaces might be limited. Francisco Ricardo has raised this issue in his essay "Behind the Narrative Interface—Aspects of Structure in Hyperfiction," where he challenges the hyperfiction community to think about its dreams and real possibilities in hyperfiction design and implementation:

> With the repetition of certain prominent techniques, it is clear that the envelope of representation is being pushed to limits that are not infinite. Authors are increasingly interpolating greater cleverness into content anatomy to compensate for the relative fixity of the interface and what it offers to the writer—limitations of features that are as true of authoring systems like StorySpace as for web browsers. How much farther can we go?

Ricardo's statement reinforces the fact that even though technology might give way to further developments to enhance representation, neither hypertext nor print might survive without its intrinsic limitations. What is interesting and of the essence in this study is how Borges apparently anticipated these technological barriers, and how he dedicated his life to exploring and challenging the power of language and the human mind. Thus, he laid out texts that pushed their readers to search for hidden revelations, call them philosophical stances or metaphysical issues, which lead the reader to the creation of infinite imaginary worlds.

Language is the medium for Borges, and that medium is the message in a Borgesian text. Borges's dream of multiple worlds can be only accessed through language and thought. The print medium is, for Borges, containment, and the challenge is to exceed it through language. Print is containment because its spatial orientation does not allow for the representation of multiple worlds. On the other hand it is also an excuse because he uses language in the print medium to exceed the limits of print. Borges does not need postprint, but his texts resemble the postprint culture before its arrival. Borges's title "The Garden of Forking Paths" and its metaphysical story suggest the possibility of a text that branches off into infinity, allowing the emergence of different stories. As Moulthrop states, "no hypertextual product can realize the strictly labyrinth of Borges' fantasy" ("Reading from the Map" 129); future advances in open hypermedia systems might allow for the creation of hypertext environments that permit the creation of a story with almost an endless number of endings. This will only be an approximation of Borges's multiple worlds, because *forking paths* and links, though they share the feature of branching off into other stories, are different in nature.

This extraordinary power of language that Borges emphasizes in "The Garden of Forking Paths" echoes Foucault's discussion of language in his essay "Language to Infinity": "Language's claim to tell all is not simply that of breaking prohibitions, but of seeking the limits of the possible, the design, in a systematically transformed network, of all the branchings, insertation, and overlappings which are deduced from the human crystal in order to give birth to great, sparkling, mobile and infinitely extendable configurations" (61). Thus, Borges, like Foucault, exploits all the potential of language, making of it the essential element for a movement towards infinity, setting aside the role of language as communication.

According to Foucault, "Language must push back to infinity this limit it bears with itself, and which indicates its kingdom and its limit. Thus, in each novel, an exponential series of endless episodes; and then, beyond this an endless series of novels" (65). These ideas are illustrated in "The Garden of Forking Paths," the very title of which suggests a story that gives way to infinite stories, a language garden where worlds proliferate in an almost endless fashion. By the same token, the title sets an ironic mood, because Borges knows of the impossibility of presenting a visible infinite number of stories through the printed medium. Thus, his only way out of his own labyrinth, and his only way to account for multiple worlds, is by referring to the power of language and the reader's imagination. Borges portrays in a daring fashion the limitations of the printed medium while at the same time elevating the power of the human mind, intellect, and language.

Borges's *forking paths* accept almost no limitations, whereas the limits of hypertext are marked by the restrictions imposed by technology or the programmer. It is impossible for hypertext to beat Borges, because Borges's texts and hypertexts are different in nature. Borges exceeds the constraints of the print culture through language. His *forking paths* do not need postprint because they have characteristics of postprint embedded in them. On the other hand, hypertext fiction writers also try to go beyond the limitations of print by creating virtual environments where readers can follow different paths within a literary work or become co-authors of the stories they read by adding new lexias.

## Two Different *Forking Paths*

Borges's short story "The Garden of Forking Paths" provided an almost perfect point of departure for discussing Moulthrop's electronic "forking paths," created using an intricate system of links. This electronic version created with a beta version of StorySpace was put to the test in Jane Yellowlees Douglas's undergraduate class in New York University in 1987.

Though an incomplete version lacking instructions, "forking paths" serves as a ground for discussion of the merits and demerits of a hypertextual approximation to "The Garden of Forking Paths."[3]

Douglas's class was divided into two groups: one half of the class was given the print version of "The Garden of Forking Paths," while the other was assigned its electronic counterpart. Instructions were kept to the point: both groups were to read the story carefully and retell it in a short piece of writing, the narrative, as they understood it. Those involved with "forking paths" were told they could navigate through the text by clicking on words in the text of each window or place, or by using a carriage return (Douglas). The students' understanding of the text could have been influenced by the fact that they did not have access to the mapping or graphic representation of the hypertext structure at that time.[4]

After reading "The Garden of Forking Paths" and Moulthrop's electronic "forking paths," students expressed their responses to the reading experience. According to Douglas, "all seven readers given the interactive 'forking paths' used the right option to move through the text, and two out of seven gave complete priority to the sense of the text that they had derived from their navigating through the hypertext structure over the actual sense of narrative itself." Throughout the reading process, students were confused because they would find a dead character in one node and the same character alive in the next narrative strand. They lacked a macrostructure that could help them grasp the general picture of the story. They were forced to create the total mental picture of the story, yet they read each node as any print reader would. From a scrap of paper of one of the "forking paths'" readers, Douglas found out that one of her students had been able to reach the precise physical center of the narrative, a place called 076. The student's account tells us the following: "After reading about 15 cells, I got to closure, but I was not satisfied that it was over, so I continued reading. I made it to the center, cell 76, and that wasn't any big revelation, either . . ." (Douglas).

In spite of their bewilderment, the students who read the electronic version sounded more pleased with the reading experience than those who read "The Garden of Forking Paths"; the latter group felt, to a certain extent, betrayed by the author. These students believed that the text had presented the clues for a universe in which multiple possibilities co-exist, yet "'The Garden of Forking Paths' seemed to them to have reneged on its promise without having provided what saw as the sort of closure appropriate to the macrostructure of the text a world of seemingly infinite possibilities where the mutually exclusive developments could unfold simultaneously" (Douglas).

Both groups of readers came out with different interpretations of "The Garden of Forking Paths" and "forking paths," not only because these works were read in different media, but also because it was harder for the former group to understand Borges's enterprise when writing "The Garden of Forking Paths." The different media used for the presentation of the text affected the outcome of the students' interpretation of the story. But not all readers of the print version missed Borges's objective; one of them was able to bring to the surface Borges's concern with multiple possibilities. In his response to the text, this reader commented:

> I figure out that Tsun's [sic] motivation throughout this story after rereading the beginning of it, but that does not seem like the point that [sic] was really trying to get put across. For all we know, the particular end used in this story may have been only one of an infinite number of possibilities down the *forking paths* of time. Since, according to the all-wise Tsui Pen, all of these possibilities peacefully co-exist in parallel dimensions, isn't it there true that we can reject this ending and make up one of our own? (qtd. in Douglas)

This student's response tackles Borges's idea of multiple worlds. From the print version the reader emerged not only with the suspicion that there is a hidden agenda in the text, but also with the possibility of adding to the story his own ending. In this sense, Borges's story relates to hypertext by allowing readers to re-imagine what they are reading in an infinite number of ways. By the same token, Borges's short story "The Garden of Forking Paths" resembles not an exploratory hypertext but a constructive one: a hypertext that allows the reader to add his own lexias and nodes.[5] In this sense, hypertext embodies Borges's impossible dream of containment. Thus, technology can only approximate itself to Borges's dream, and so far it has not been able to materialize it because it is impossible to create an infinite virtual environment.

## Forks and Links

Borges's forking paths admit no rivalry in the power they have to give way to mental constructs. Forking paths and links are different in nature, yet Borges's forking paths share with links the postmodern stance that renders more power to the reader than to the author of a text and highlights the interactivity of the reading process. Borges's ideas of forking paths and multiple paths that represent multiple times have been adopted in hyperfiction. According to Licia Calvi, the structure presented by Borges in "The Garden of Forking Paths" refers to a combinatorial structure where "the author's strategy is revealed by this combinatorial embedding" (Calvi 101).

The writer of "The Garden of Forking Paths" uses a selection procedure that Calvino calls "the labyrinth challenge,"[6] which, together with the "garbage axiom," allows the author to express his gnosiological-cultural search through structure (Calvino 101).[7]

Borges, a master of labyrinths, challenges the reader to take a position and to traverse the path of her choice. The reader determines through a process of selection whether she is interested in getting to the end of the novel or in coming to terms with the hidden revelation presented to the author. In order to dismantle the secret of the labyrinth of forking paths, the reader has to be willing to challenge the puzzle to a solution laid out by Borges. If Borges's ideas are reflected in hyperfiction, how do forks and links make a difference from the reader's point of view?

Calvi states that "the hyperreader does not differ from the traditional reader formally, for readers of both hypertext and linear works are in the situation of dynamically building themselves while reading" (108). The basis for understanding the differences between hyperreaders and normal readers lies in the notion and the role of the link as the carrier of meaning and as a catalyst to generate knowledge. In the case of Borges's "The Garden of Forking Paths," the reader has to envision and re-create in his mind the hidden structure developed by the author. The reader of "The Garden of Forking Paths" recreates the text through language, a language that is language to infinity. In so doing, the text resembles a hypertext that allows readers to re-imagine what they are reading. In an electronic version of the same story, the hyperreader would progress in the development of the story as well as in the discovery of the physical labyrinth.

It was not Borges's intention to provide the whole layout of his plan. His strategy can only be materialized in someone's mind. Thus, Borges's story provides cues to be developed in the readers' imaginations. Borges's cues pave paths to infinity. Hyperfiction links, on the other hand, in spite of being part of an enclosed system, trigger a number of possibilities and act as stimulating carriers of meaning. It would be unfair to analyze them from a traditional standpoint because they belong to the electronic culture, even though they have ancestors in some print-based stories. According to Wendy Morgan, "Links pre established by the writer may encourage the reader's further associative leaps: a text that displays the patterns of its weaving promotes the minds tendency to play over and through its web to produce other readings" (209). We should therefore look at links as potential sources of inspiration and critical thinking since they are, as Michael Joyce states in his introduction to *afternoon: a story,* "words that yield." From a poetic perspective, we could look at links as poetic texts that, according to Susana

Pajares Tosca, "encourage readers to explore context in the search for an interpretation, rewarding them with the accessing of a wide range of implicatures" ("Lyrical Quality of Links" 218). The ability to move through them is part of the aesthetic experience that hypertext offers. In this sense, the technology present in hypertext represents a means to an end. Links not only depict a plot but also invite the reader to undergo a critical process in the search of meaning. Ultimately, their use supplements reason in a way that it promotes a world of multiple interpretations. It remains for the advances of technology to demonstrate how far hyperfiction links can go in creating environments where readers become co-authors of their own stories, stories that suggest an almost endless branching off into infinity. Until then, technology and its hyperlinks will only be able to approximate to Borges's achievements as expressed via his infinite *forking paths.*

## Notes

[1]   According to Meyers, Blair, and Hader, Robert Coover began the Hypertext Hotel for his Hypertext Fiction Workshop at Brown University in 1991, using Intermedia, and imported it to StorySpace in 1993. Later on, this historic collaborative document was imported into a system where writing students have continued to extend and write it. In addition, other people unaffiliated with Brown have contributed to the text and incorporated it with the other, newer areas of the system. For further reference please refer to Meyers, Blair, and Hader, "A MOO-Based Collaborative Hypermedia System for WWW," or to http://graphics.cs.brown.edu/research/pub/papers/wwwmoo.html. *M is for Nottingham* is another example of an online collaborative writing project where participants created a character and wrote segments of a mystery drama. See http://califia.us/NottinghaM/.

[2]   Michael Joyce coined the phrase "words that yield" to make reference to the links in hypertext.

[3]   For Moulthrop's detailed description of "forking paths," see "An Anatomy of 'forking paths'" in the CD-ROM accompanying *The New Media Reader*, edited by Noah Wardrip and Nick Monfort.

[4]   According to Douglas, the read-only component of the beta version of StorySpace did not include the means for readers to examine the cognitive map of the hypertext structure, nor did it make available to readers a menu of paths branching out from each node properties now readily available in some versions of interactive narratives written in StorySpace.

[5]   For a discussion on exploratory and constructive hypertexts, see Michael Joyce's *Of Two Minds* 39–59.

[6]   Term used by Italo Calvino in "La sfida al laberinto" in *Una pietra sopra.*

[7]   Term used by Italo Calvino and discussed in Musarra-Schroeder *Il laberinto e la rete.*

# Chapter 3

# The Significance of the Theories of Deleuze, Guattari, and Eco to Understanding Borges's Work and Hyperfiction

The world has become chaos, but the book remains the image of the world: radicle-chaosmos rather than root-cosmos. A strange mystification: a book all the more total for being fragmented. At any rate, what a vapid idea, the book as the image of the world.

Gilles Deleuze and Félix Guattari, *A Thousand Plateaus: Capitalism and Schizophrenia*

The theoretical framework developed by Gilles Deleuze and Félix Guattari in their book *A Thousand Plateaus: Capitalism and Schizophrenia,* in conjunction with Umberto Eco's development of the text as an open work, his classification of labyrinths, and the role he assigns to the reader, provides an optimal framework of reference to analyze Borges's fiction through the lenses of hypertext. In order to accomplish this goal there are two perspectives that I want to consider. On the one hand I will focus on the issues of decentering, striated and smooth spaces, and nomadic thought as they relate to Borges's "The Garden of Forking Paths" and "The Library of Babel." On the other hand, Eco's development of the text as an open work, his classification of labyrinths, and the role he assigns to the reader contribute to a new perspective on the analysis of the Borgesian works previously mentioned.

The main commonality among these thinkers' positions is that they have succeeded in developing theories that allow the reader to interpret literature as a challenge, as a space that needs to be traversed and recreated in order to be understood. The philosophical and metaphysical claims made by Deleuze, Guattari, Eco, and Borges allow the reader to better understand the role of the new emerging technologies because they provide a revolutionary look at the canonical premises of literature.

In *A Thousand Plateaus: Capitalism and Schizophrenia,* Deleuze and Guattari elaborate a theory that could be applied to many aspects of our lives, such as sociology, politics, and literature. Deleuze and Guattari propose is a new stand, inviting us to create a space where hierarchies are challenged and decentralization occurs.

From Deleuze and Guattari's perspective, a book is not an unchangeable artifact but an assemblage where words and lines open up spaces for thought. Deleuze and Guattari's contention states the following:

> In a book, as in all things, there are lines of articulation or segmentarity, strata and territories; but also lines of flight, movements of deterritorialization and destratification. Comparative rates of flow on these lines produce phenomena of relative slowness and viscosity, or on the contrary, of acceleration and rupture. All this, lines of this kind, speeds, constitutes an assemblage. (3–4)

As a consequence, "[l]iterature is an assemblage" (4); it functions as a root with infinite extensions and connections. Even though Deleuze and Guattari's metaphor is arboreal, the structure they have in mind differs from that of a tree. According to their rhizomatic view of literature, "[a] book exists only through the outside and on the outside" (4). Deleuze and Guattari see the book as a literary machine and as an organism whose value resides not so much in its inside but in the connections it makes with other organisms and the extent to which it is able to be metamorphosed into other multiplicities. Within this framework, literature resembles an assemblage and an intricate net of connections in a constant state of formation and re-creation. Hence, the value and meaning of a book resides in the way it affects its readers as well as its environment.

Eco has taken up Deleuze and Guattari's ideas of the rhizome theory to elaborate his own definition of net. In his book *Semiotics and the Philosophy of Language,* Eco defines the net by stating that it "is not a tree" (81), reaffirming that the net has no definite or fixed center and that even though the net has tree-like branches, all the branches attempt to interconnect to each other. This idea of literature as an assembling or interconnecting web resembles Ted Nelson's visionary statement that everything is "intertwingled,"[1] an idea that later was substantially materialized by the invention of the World Wide Web. Moreover, each of these interpretations of net and literature reinforces Borges's claim that "A book is not an isolated being: it is a relationship, an axis of innumerable relationships" ("A Note on (toward) Bernard Shaw" 214). Within this framework, Deleuze and Guattari's theory as well as Eco's classification of labyrinths serve to illustrate the connection between literary theory, Borges's fiction, and hypermedia.

### Rhizomatic Organisms

Deleuze and Guattari developed a theory based on the organic idea of the rhizome, which embodies the principles of connection, heterogeneity, multiplicity, and the assigning of rupture. The rhizome extends itself by establishing connections with everything else. It does not necessarily link similar traits; on the contrary, the rhizome is able to make connections with diverse modes of coding. As a consequence, a rhizomatic structure does

away with vertical hierarchies, so that no supreme force rules or imposes its traits upon subservient subjects. A system of this kind does not accept dichotomy and/or dualism; instead, it opens up to establish a polyvocal net that constantly welcomes and links elements that might be similar or very different in nature. It follows that a rhizome system is never static; there is no subject or object due to the constant state of deterritorialization and motion. As the rhizome segments break up and produce ruptures,[2] they create new lines of flight that are part of the rhizome. According to Deleuze and Guattari, these lines of flight are seen as a passageway and storage of living strata (12). Thus, the ever-growing extensions of the system do not represent it but rather are part of the system. From this perspective, "the book is not an image of the world. It forms a rhizome with the world" (Deleuze and Guattari 11). Because it presents literary works as one more extension of the rhizome, Deleuze and Guattari's contention breaks with the concept of the book as a model of the world or the world as a model for the book. The book does not imitate the world or vice versa. There is no binary logic or direct correspondence between different elements. In reference to this issue, Deleuze and Guattari assert:

> There is no longer a tripartite division between a field of reality (the world) and a field of representation (the book) and a field of subjectivity (the author). Rather, an assemblage establishes connections between certain multiplicities drawn from each of these orders, so that a book has no sequel nor the world as its object nor one or several authors as its subject.…The book as assemblage with the outside, against the book as image of the world. A rhizome-book, not a dichotomous, pivotal, or fascicular book. (23)

Perhaps two of the principles of the rhizome theory most relevant to this study are those cartography and nomadic thought. Deleuze and Guattari distinguish a map from a tracing and see a tracing as "something that comes ready–made" (12). Whereas maps construct and are always in a state of becoming, tracings describe something that is already there from the start or exists in a latent state ready to emerge. Whereas in Borges's "The Garden of Forking Paths," tracings are represented by the detective narrative and the clues that the author presents in reference to the existence of multiple plots, in hyperfiction tracings can be related to the commands in the program behind each hyperfiction. These digital tracings are embedded in the program, and even though they have been there from its inception, they are not always activated.

The nomadic quality of maps indicates that there is always a space for change and movement to be charted. According to this principle, it is possible to relate the multiple entries of the map to the multiple entries of

hyperfiction where the reader is able to select one of the several starting points suggested by the author. The idea of a map is also associated with action because its own lines of flight promote deterritorialization and destratification to constantly modify the rhizome. Through the constant movements of deterritorialization and destratification, the rhizome becomes an element in a constant state of becoming, an idea that is also embodied in hyperfiction, as the reader's action causes deterritorialization and destratification within the electronic text.

Nomadic thought implies a continuous movement into an open space as well as constant territorialization and deterritorialization. This continuous movement takes place between a striated space and a smooth space. Whereas the smooth space refers to a close local vision, the striated space relates to a more distant vision and global approach. Movement creates a smooth space, a territory that emerges between the presences of regulatory forces. It is for this reason that neither the striated space nor the smooth space exists in its own pure form but merely as an interwoven fabric; they contaminate each other. Hence, nomadic thought implies a constant movement from smooth spaces into striated spaces and/or vice versa: "Yet the two are linked and give each other impetus. Nothing is ever done with: smooth space allows itself to be striated, and striated space reinstates a smooth space, with potentially very different values, scope, and signs. Perhaps, we must say that all progress is made by and in a striated space, but all becomings occur in smooth space" (Deleuze and Guattari 486).

In "The Garden of Forking Paths," this constant movement from a smooth space to a striated space and vice versa is portrayed by the reader's focus either on the detective plot or on the metaphysical ideas portrayed in the story. The detective story stands for the smooth space where all the hints lead to the unveiling of the metaphysical plot. The two narratives do not exist in isolation; they enrich each other's role in the story as a whole. Thus, the concept of multiple outcomes adds intrigue and complexity to the straight-forward detective plot.

The notion of multiple entries, which is so common in hyperfiction, harmonizes with the structure of a rhizome system. A rhizome is made up of plateaus that are always in the middle. There is never a marked beginning or end. Deleuze and Guattari call a "plateau any multiplicity connected to other multiplicities by superficial underground stems in such a way as to form or extend a rhizome" (Deleuze and Guattari 22). Their own book is an example; there is no predetermined way to read it. It has a rhizomatic structure since each chapter is thematically linked to all the other chapters of the book. Like the ever-moving faults of the earth, plateaus create a fascinating space for

exploration. They pose an invitation to be meticulously explored in order to excavate and elucidate whatever lies hidden between them. Thus, the nomad subject who attempts to deal with these plateaus will have to thoughtfully excavate their territory in order to traverse the different strata.

From this perspective, fiction becomes a meta-language, a plane described as "a part aside, as ungiven in that to which it gives rise" (Deleuze and Guattari 266). These planes or hidden unities are discovered and brought forward by the reader as she moves within and out from the literary labyrinths in an attempt to liberate herself. Still, there are other interpretations or planes also related to nomadic thought. These planes are known as the plane of consistency and the plane of development and organization. The plane of consistency makes reference to "an abstract design" (Deleuze and Guattari 267). From Deleuze and Guattari's perspective, the plane of consistency is also a plane characterized by constant proliferation and transformation. Therefore, the rhizome "constitutes linear multiplicities with $n$ dimensions having neither subject nor object, which can be laid out on a plane of consistency, and from which the One is always subtracted (n-1)" (21). Basically, the plane of consistency is an aggregate of fuzzy and heterogeneous elements, whereas the planes of development and organization, as their names imply, refer mainly to form and substance. The tension between the plane of consistency and the planes of development and organization is constant and relevant for the rhizome structure. It is the movement between these planes that makes the imperceptible perceptible. In short, the constant tension, struggle and deterritorialization promote the emergence of something new.

### Rhizomatic Features in "The Garden of Forking Paths" and in Hyperfiction

Like most hyperfiction writers, Borges strives to overcome the technological limitations of print in order to construct spaces that give way to the idea of multiple times, multiple segments, and/or multiple stories. This kind of literary work is by nature nomadic art because it encourages readers to go beyond the plot in order to perceive the philosophical and/or metaphysical implications embedded in the stories. Borges's "The Garden of Forking Paths" and hyperfictions like Moulthrop's *Victory Garden* seduce readers into engaging and intellectually charged readings that emphasize the premises of nomadic thought as described by Deleuze and Guattari. In doing so, readers traverse and create multiple trajectories. What really matters in this kind of reading are the passages and the new trajectories discovered by the readers as they move from a striated space into a smooth space, or vice versa.

The plot and the subtle references to the concept of multiple times stand for the tracings as elaborated by Deleuze and Guattari. Each reading or reader's interpretation contributes to the creation of a new map that emerges as the reader proceeds through the different layers of the story to discover, along with the characters, that in Ts'ui Pên's world the seemingly chaotic universe was the chaotic novel itself. The phrase "'to various times, but not to all' suggested the image of bifurcating time, not in space" ("The Garden of Forking Paths" 98). At this point in the story, the reader is challenged to move beyond the historical narrative plot to ponder metaphysical issues concerning the existence of multiple simultaneous times that echo Deleuze's and Guattari's plateaus as elaborated in *A Thousand Plateaus*.

The plateaus defined by Deleuze and Guattari resemble the lexias of hyperfiction as well as the pages of the World Wide Web. In hyperfiction, not all the lexias follow a natural logic of association. More often than not, hyperfiction authors play with the unexpected. They attempt to create literary texts that deal with two or more simultaneous realities. Each entry in hyperfiction establishes a unique reading of the narrative because each entry leads to a path and ignores many others. Within this context, it is possible to imagine that a hyperfiction resembles a map in a continuous state of development where action leads to a process that promotes territorialization and destratification to constantly modify the rhizome. This phenomenon is illustrated by Moulthrop's *Victory Garden,* which was programmed to abide by the reader's decisions, which in turn determine a series of cascading binaries and thus lead the reader to one of the multiple paths of the story.[3]

*Victory Garden* takes up the topics and the metaphysical ideas presented by Borges in "The Garden of Forking Paths." However, while "The Garden of Forking Paths" deals with the events of World War I, *Victory Garden* takes us back to the mass media era of the Gulf War. In both stories, the reader is encouraged to transcend the text, to reach beyond the plot to envision the possibility of multiple times. When discussing "The Garden of Forking Paths," Borges's character Stephen Albert acknowledges Ts'ui Pên's interest in the problematic issue of time. Albert makes the reader and his interlocutor aware that "this is the only problem that does not figure in the pages of *The Garden*" ("The Garden of Forking Paths" 99). In so doing he leads others to believe that by omitting this word Ts'ui Pên has brilliantly laid out the main topic of his novel. Similarly, in the lexia "Images,"[4] the narrator in *Victory Garden* tells us: "It's a familiar feast, all fragments and repetition stuck together with a paste of groundless spec. And of course it's what we don't see that counts" ("Images").

"The Garden of Forking Paths" and *Victory Garden* are landmark literary texts that embody Deleuze's and Guattari's theoretical framework, which challenges readers to break free from canonical interpretations of texts. Within this framework, the smooth space stands for the space where the literary machine develops, whereas the striated space represents the space that abides by the literary canon. The struggle between these two spaces allows the nomadic reader to create new smooth spaces and to reverse striated spaces to a smooth environment that keeps the literary machine in motion.

By elaborating and theorizing about the principles mentioned above, Deleuze and Guattari laid out the basis for the creation of smooth spaces to promote the advancement of humanity. The acknowledgment of these spaces is essential to understanding the postmodern features present in Borges's writings and in hyperfiction. By allowing the reader to take a more relevant role in the creation of the literary text, Borges succeeded in creating a literary work that highlights the role of the reader as creator of the literary text. By the same token, Borges's text breaks away from the canonical role of the author as sole creator of the text. Deleuze and Guattari's rhizome theory challenges the reader to establish new connections within and among literary works and to put them to "strange new uses" (15). This statement reaffirms the need to view the innovative writings of Borges and the first generation of hyperfiction writers from a new perspective. Similarly, it challenges readers to find new ways to understand and interpret the new media.

This convergence of ideas and themes among Deleuze and Guattari's theory, Borges's stories, and hyperfiction provides a new ground to critically analyze Borges's stories and hyperfiction. Above all, it takes into account and acknowledges Borges's groundbreaking ideas and legacy in the still evolving genre of hyperfiction.

## Eco's Theory of Semiotics

Umberto Eco has taken up Deleuze and Guattari's theory of the rhizome in his development of a general theory of signs. Such theory is based on the principles of unlimited semiosis, encyclopedia, and abduction. Eco does not recognize the one-to-one relation between signifier and signified (*Semiotics and the Philosophy of Language* 39). On the contrary, his theory of semiotics acknowledges an encyclopedic notion of code, whereby everything is related to everything else in a net of meanings that prove open to an infinite variety of interpretations. Thus, Eco acknowledges that there is a sign that "is either not coded, vaguely coded or in the process of being coded through one of the most daring of inferences, that of *abduction* or *hypothesis*" (39). Within

Eco's theory, abduction is defined as "the tentative and hazardous tracing of a system which will allow the sign to acquire its meaning" (40). From this perspective, interpretation implies the act of taking one path among the many offered by the rhizomatic labyrinthine structure. By developing this principle, Eco almost does away with principles such as structure and hierarchy and acknowledges the changing nature of our world. He achieves this innovative approach by providing a tentative path to his readers. In reference to the principle of unlimited semiosis and the encyclopedic traits that shape his theory, Eco states the following:

> If the so-called universals, or metatheoretical constructs, that work as markers within a dictionary-like representation are mere linguistic labels that cover more synthetic properties, an encyclopedia-like representation assumes that the representation of the content takes place only by means of *interpretants*, in a process of unlimited semiosis. These interpretants being in their turn interpretable, there is no bidimensional tree able to represent the global semantic competence of a given culture. Such global representation is only a semiotic postulate, a regulative idea that takes the format of a multidimensional network.... (68)

Eco's semiotic theory is in tune with the technological changes of our times, and it asserts a new function of art and thus print and digital literature. In the first preface to *Opera aperta*, Eco states that contemporary art seeks a solution to this crisis by offering us a "new way of seeing, feeling, understanding and accepting a universe in which traditional relationships have been shattered and new possibilities are being laboriously sketched out" (qtd. in *The Open Work* xv). *Opera aperta* provides a significant background on the concepts of openness, the idea of multiplicity, and the role of the reader and writer in the process of interpretation. Eco's poetic of the open work sees the text as a work in movement to be completed by the addressee. The author offers the audience a text that embodies a potential number of paths and resolutions. The reader, on the other hand, engages herself in an interpretative dialogue with the text, which might give way to outcomes not even planned by the author. What makes modern open works different from their ancestors is the fact that modern writers have consciously accepted the participation of the reader in the creative process of the text.

Eco understands that, as at other points in history, the scientific and technological advances of the twentieth century have influenced literature. According to Eco, works like Mallarmé's *Livre* and Joyce's *Ulysses* disregard the Copernican hierarchical structure and challenge the reader with a structural organization that exploits the possibilities of discontinuity and multiplicity elaborated by modern and postmodern physics. Eco regards both texts as open works that represent a possible deconstructed mobile unity

typical of non-Euclidean geometry. By the same token, several of Borges's texts embody the idea of open works because they allow the reader to see the plot from different perspectives that depart from a traditional analysis. "The Garden of Forking Paths" displays not only the plot of a detective story but also the issues of indeterminacy and discontinuity present in the Einsteinian physics. "The Library of Babel" is also an open work because its interpretation entails not only an understanding of the plot of this story but a search for meaning in a rhizome of words which resembles—though it is not absolute chaos. Thus, Eco's theory of the "open" work can be applied to these Borges stories because they demand a high degree of participation on the part of the reader to recreate the text. Even though these works might be seen as organically complete texts, these short stories have been deliberately organized by the author in order to challenge the reader's ability to exhaust the text. In reference to this topic Eco states:

> Every performance explains the composition but does not *exhaust* it. Every performance makes the work an actuality, but is itself only complementary to all possible other performances of the work. In short, we can say that every performance offers us a complete and satisfying version of the work, but at the same time makes it incomplete for us, because it cannot simultaneously give all the other artistic solutions which the work may admit. (*The Open Work* 15)

From this perspective, Eco's theory supports Borges's intellectual challenge of the possibility of multiple worlds. Whereas the printed version of "The Garden of Forking Paths" can only present the reader physically with two plots, Borges has laid out his story in such a fashion as to allow the reader to intellectually devise more than two imaginary worlds. In order to accomplish that, the reader is impelled to take one of the many forking paths that make up the rhizomatic structure of the text.

This idea of multiple interpretations is rooted in Eco's belief in a process of unlimited semiosis. He envisions an encyclopedic approach based on a labyrinth metaphor. This topographical image allows him to elaborate a classification of labyrinths that provides new insights to the understanding of postmodern literature, especially Borges's short stories and those stories belonging to the new genre of hyperfiction.

### Eco's Classification of Labyrinths

A certain fascination with the intricacies of corridors and labyrinths of medieval convents led Eco to develop his own classification of labyrinths. Such classification encompasses three types of labyrinths whose designs have been greatly influenced by the image of the Porphyrian tree. In Eco's

words "The Porphyrian tree represented the most influential attempt to reduce the labyrinth to a bidimensional tree. But the tree again generated the labyrinth" (*Semiotics and the Semiology of Language* 80).

Eco's classification of labyrinths includes the classical labyrinth, the maze, and a third type of labyrinth that he refers to as a net. According to Eco, the linear labyrinth of Crete is an example of a classical labyrinth and it has little excitement except for the Minotaur in its center (80). From Eco's perspective, "the Ariadne thread is of no use since one *cannot* get lost: the labyrinth itself is an Ariadne thread" (80). The second type of labyrinth described by Eco is called the maze. Eco claims that such a labyrinth provides more possible choices, although some paths may lead to dead ends and one might be obliged to move backwards. Contrary to the classical labyrinth, the maze allows more freedom and brings up the possibility of trial and error. In reference to this maze, Eco states: "A maze does not need a Minotaur; it is its own Minotaur: in other words, *the Minotaur is the visitor's trial and error*" (81). Finally, Eco elaborates the idea of the labyrinth with a net line structure where "every other point can be connected with every other point, and, where the connections are not yet designed, they are, however conceivable and designable" (81). Even though this type of labyrinth is arboreal in nature because its paths extend and ramify like the branches of a tree, the net-like structure of this labyrinth does not comply with the idea of a tree. From Eco's perspective, a labyrinth as a net "has neither a center nor an outside" (81). It is continuously branching off and moving towards infinity.

Eco's idea of the labyrinth as a net was taken up from "the vegetable metaphor of the rhizome suggested by Deleuze and Guattari" (Eco, *Semiotics and the Philosophy of Language* 81). A rhizome implies structures whose stems extend and proliferate horizontally in an attempt to establish connections with other stems or shoots. Thus, a labyrinthine structure of this type cannot be seen globally but just in parts. This type of net with an infinite branching is chaotic in nature and demands a challenging attitude from whoever decides to come to terms with it. According to Eco, "in a rhizome blindness is the only way of seeing (locally), and thinking means to *grope one's way*" (82).

From the literary point of view, a piece of writing that portrays the characteristics of this type of labyrinth dares the reader to make her way through a text which contains more than one plateau. Thus, reading implies something more than reading for the plot. It also implies a search for a structure that in turn gives way to a metaphysical idea as in Borges "The Garden of Garden of Forking Paths," where the author subtlety leads the reader to face the possibility of the existence of alternate and multiple times.

The illuminating insights that stem from the theories Deleuze and Guattari and Eco and from Borges's work provide a fruitful terrain to think critically about the possibilities for interpretation of hyperfiction. By the same token, they allow readers to explore Borges's work from a new perspective, a perspective that takes into account the rapid advances of technology as well as the fundamental features of the rhizome theory and its labyrinthine implications.

# Notes

1  For a detailed explanation of Ted Nelson's phrase "Everything is intertwingled," refer to *Dream Machines* 31.

2  According to Deleuze and Guattari, there is a rupture in the rhizome whenever segmentary lines explode into a line of flight, but the line of flight is part of the rhizome. For further explanation refer to *A Thousand Plateaus: Capitalism and Schizophrenia* 9.

3  In a personal e-mail communication, Moulthrop explains: "The readings do change according to a set of binary constraints (often multiple, cascading binaries), and this effect makes it unlikely that a second reading will resemble the first reading."

4  I give references to *Victory Garden* by stating the title of the node to which I refer.

# Chapter 4

# "The Library of Babel," "The Garden of Forking Paths," and the World Wide Web as Rhizomatic and Hypertextual Environments

We know that discourse has the power to arrest a flight of an arrow in a recess of time, in the space proper to it.

Michel Foucault, "Language to Infinity"

### Depletion and Organization: Two Historical Concerns

Nowhere is the hypermedia system more evident than in Borges's "The Library of Babel." This short story, which was written in 1941, epitomizes the unique features of the modern electronic databases. Even though Borges was geographically and chronologically distant from the ideas proposed by Ted Nelson in his Project Xanadu in 1987,[1] Borges created an imaginary universe that has been taken up by man's ambition to create a universal digital library. In "The Library of Babel," Borges foreshadows an infinite and indefinite library similar to the electronic libraries that have existed since the sixties. These electronic libraries, like "The Library of Babel," attempt to include all the texts that have been written as well as those that will be written in the future. Borges's point, however, is that the quest for the book that contains all books is pointless, for it is impossible to achieve totality. As a forerunner of hypertext, Borges's story contains a salutary warning, even if it foretells of the existence of an indefinite library and the overwhelming amount of information at our hands through hypermedia environments.

"The Library of Babel" begins with a declaration:

When it was proclaimed that the Library comprised all books, the first impression was one of extravagant joy. All men felt themselves lords of a secret, intact treasure. There was no personal or universal problem whose eloquent solution did not exist—in some hexagon. (83)

Borges's words are enacted today when millions of people connect to the Internet, searching amidst an over-abundance of information. In its major effect—exponential increases in information—the Internet redoubles, to say the least, the primary result of the revolution in printing. In "The Library of Babel," Borges mocks the thinkers' quest for the Summa Sciencia as nothing more than an aimless march from hexagon to hexagon. Borges's parody

emphasizes man's disappointing failures in the face of the overwhelming amounts of information. Borges writes, "The uncommon hope was followed, naturally enough, by deep depression. The certainty that some shelf in some hexagon contained precious books and that these books were inaccessible seemed almost intolerable" (84).

In the eighteenth century, as in the fictive world of Borges's "The Library of Babel" and in today's hypermedia environments, the abundance of information gave way to an almost obsessive search for knowledge. In today's world, the Internet raises hope as well as fear among some of its users, just as reading did in the eighteenth century.[2] There is no doubt that lack of a systematic organization of information leads to frustration for the characters that walk through the Library of Babel or for those who navigate the virtual space of the Internet. Within this framework, the Internet is seen as a tool that, because of its continuous growth, is unable to exhaust its organic textuality,[3] causing a sense of disillusionment in those who attempt to master it in its totality.

The novelty and innovative features of hypertext have their ancestors in the oral tradition as well as in scribal society. Whereas the oral tradition counted on the association of ideas and memorization to disperse and preserve knowledge, hypertext imitates man's processes of association and supplements the human memory by providing, whenever possible, a visible path of links. The obvious similarities between scribal culture and hypertext are intertextuality and the degree of importance they both assign to authorship. This last issue has triggered controversial discussions among authors, critics, and hypertext writers. Despite the generally favorable and almost idealized view of the author, there have always been people who do not regard authorship as an issue for great concern. In his book *Medieval Texts and Their First Appearance in Print,* E. P. Goldschmidt affirms:

> …the indifference of medieval scholars to the precise identity of other authors whose books they studied is undeniable. The writers, on the other hand, did not always trouble to "quote" what they took from other books or to indicate where they took it from; they were diffident about signing even what was clearly their own in an unambiguous and unmistakable manner. (116)

However, the advancement of the scribal technology into that of print gave way to a plethora of theories, ranging from those that highlight the role of the author to those that have attempted to rescue the value of the text and the reading act more than to defend the hegemonic role of the author.

Ideas such as those developed by Foucault in his essay "Language to Infinity" and by Barthes in reference to the definition of lexias were first put into practice by authors who experimented with language and structure

within the print medium.[4] Hypertext theorists such as Michael Joyce, Stuart Moulthrop, and George Landow later on developed these ideas through their hypertextual works and theories, which highlight the role of the text and the reader.

## Postmodern, Decentralized, and Kinetic Worlds: Hypermedia, the World Wide Web, and "The Library of Babel"

As stated earlier, the World Wide Web, which is a based hypertext system developed by Tim Berners-Lee and other researchers at CERN,[5] is one of the most eloquent representatives of hypermedia systems. Today's hypermedia systems have reached beyond our wildest imagination. They provide an overwhelming amount of information, and they attempt to replicate a synthesis of man's sensory and thinking functions. A clear example of this synthesis is the fast and intensive implementation of and research on speech recognition and on how computers can imitate the functions performed by our senses.[6] All these technological advances have led to man's insatiable hunger for Web-based knowledge in an environment where the search engine becomes a portal to man's inquiries and search for answers. It is as if man were trapped by a similar obsession to the one that Borges's characters faced in "The Library of Babel."

In "The Library of Babel," Borges's portrays man's inability to find the infinite and perfect book. Thus, Borges seems to prophesy the predicament of those in the twenty-first century who attempt to find all the answers to their problems in the Internet. From this perspective, Borges's "The Library of Babel," representing the limitations of printing, may be read today as a warning about the limitations of hypermedia systems.

In this respect, Borges's stories anticipate poststructuralist ideas. Specifically, both Julia Kristeva in her theory of intertextuality and Jacques Derrida in his work on deconstruction develop salient poststructuralist ideas implicit in the world of Borges's "The Library of Babel" and in hypermedia environments. Within this framework, it is possible to analyze "The Library of Babel" through the lenses of postmodern theory and hypertext.

Intertextuality is a compelling issue in "The Library of Babel." According to Michael Worton and Judith Still, "[t]he theory of intertextuality insists that a text (for the moment to be understood in the narrower sense) cannot exist as a hermetic or self-sufficient whole, and so does not function as a closed system" (1). This theory is often illustrated in Borges's texts because he believed that "[l]iterature is not exhaustible, for the simple and sufficient reason that no single book is. A book is not an isolated being: it is a relationship, an axis of innumerable relationships" ("A Note on (toward)

Bernard Shaw" 214). Most of Borges's texts abound in multiple references to other works, some of which are suspicious sources of information. Although characters often bluntly refer to reality or fiction, in many cases the edge between reality and fiction is blurred, so Borges can insist that his story gains its meaning in relation to the texts around it and embedded in it. As a consequence, the reader becomes part of the work as she elaborates these corrections. In "The Library of Babel," Borges states that the library contains "the interpolations of every book in all books" (83). The books in the library are not texts, but intertexts, and as such they are similar to hypermedia environments. Each Web page is linked to other sites in an almost infinite web fashion. If we look at Borges's imaginary library of Babel and bear in mind Roland Barthes's concept of lexias, each intertext could represent a lexia that relates to another lexia or intertext.

Borges's purposeful mind and literary games echo in his fallacious attributions to authors who do not exist and by his persistent claim that he is not the author of his own stories. In the prologue of *Ficciones,* for instance, Borges claims, "I am not the first author of the narrative titled 'The Library of Babel,' those curious to know its history and its prehistory may interrogate a certain page of N 59 of the journal Sur, which records the heterogeneous names Leucippus and Lasswitz, of Lewis Carroll and Aristotle" (15). By stating that he is not the first author of "The Library of Babel," Borges complicates the idea of authorship; he moves it away from the idea of an irrevocable and unique creator of a text and toward the idea of a creator of texts previously created by his ancestors.[7] In so doing, Borges was not only decentering the literary world but also rethinking and elevating the role of the reader. The roles of the text and the reader are crucial to Borges's work. It is through the act of reading that the reader creates her own construct and thus writes a unique text.

The Library, which in Borges's world equates to the universe, can only exist as a product of the reader's intellect. From this perspective, the library exists only as a result of man's use of language and intellect. In her search for meaning, the reader is forced to deal with two realities. On the one hand, there is an almost obsessive symmetrical description that could be easily visualized. On the other hand, the abundance of information converts the perfect order of this world into chaos. The constant and tireless search for meaning in this almost unintelligible matrix of texts is the ultimate message in "The Library of Babel." It is up to the reader to meticulously search for the metaphor in this story. Once again language is in the reader's hand and at her disposal to recreate the text. In this particular story, Borges acts like a

hypertext programmer who lays out the different parts of the story for the reader to assemble.

At this point, it is interesting to compare "The Library of Babel" and "The Garden of Forking Paths" from a perspective that takes into account Borges's use of language in these two stories. In "The Garden of Forking Paths" Borges leaves open an infinite number of options to the reader, while in "The Library of Babel," his puzzle to a solution is more definite. In his essay "Language to Infinity," Foucault asserts:

> In "The Library of Babel" everything that can possibly be said has already been said: it contains all conceived and imagined languages, and even those which might be conceived or imagined; everything has been pronounced, even those things without meaning, so that the odds of discovering even the smallest formal coherence are extremely slight, as witnessed by the persevering search of those who have never been granted dispensation. And yet standing above all these words is the rigorous and sovereign language which recovers them, tells their story, and is actually responsible for their birth. (66)

In this way, both the library and the hypertext environments project movement and move towards infinity. Both systems act as catalyst elements in the production of an unlimited number of stories. On the one hand, Foucault's view of language challenges the reader to see the language system as an almost infinite reservoir of texts. On the other hand, hypertexts also generate an infinite number of mental associations that, mediated through language, give way to an almost endless number of stories. From this perspective, language and links share one intrinsic trait: they are constantly moving into infinity. By the same token, the books in "The Library of Babel" are in a constant state of interpolation, and they continuously refer to one another. Through language, the reader of Borges's story attempts to make sense of what at first glance appears to be an absolutely chaotic and unintelligible situation. In this way, both the library of Babel and hypertexts are the embodiments of Foucault's ideas as expressed in "Language to Infinity."

The library resembles a closed system even though through language it can extend indefinitely. Hypertext systems are also usually closed systems that give the impression of extending indefinitely. Yet, open hypermedia environments do exist that allow for a greater expansion and development on the part of the user. The library of Babel and the World Wide Web both represent denumerable infinity; although the number of items composing them can theoretically be "counted," the end can never actually be reached.

For example, if we imagine the World Wide Web as an open operating system, we can say figuratively that there is no end to the World Wide Web,

a system that keeps branching infinitely, limited only by the technological possibilities of the time, and that metaphorically presents the idea of a never-ending space.

Another interesting similarity between the library that Borges describes in his story and the World Wide Web is the fact that neither of them has a fixed center. They are both in a constant state of becoming: the library is in a constant flux because each reading of a book establishes connections to novel experiences, and thus new links are established to other works. In reference to the library, Borges states: "The library is a sphere whose consummate center is any hexagon, and whose circumference is inaccessible" ("The Library of Babel" 80). In the library of Babel, as in the World Wide Web, the center could be anywhere or nowhere. What really matters is not whether the center is found or not, but the trajectories traveled, the stories read, and the associations established in the nomadic process of reading. Finally, it is the search for meaning in the library as well as in the virtual world that makes the travel worthwhile. The reader must undertake the task of creating meaning out of what is presented as absolute chaos.

As a premonition of the technology of today, Borges also describes a superstition held by some librarians in Babel of the time when "in some shelf of the hexagon, men reasoned, there must exist a book which is the cipher and perfect compendium of all the rest" (85). Though at first glance this perfect compendium could be compared to the World Wide Web, such an approach could not be further from the truth. The book that Borges describes is like the work of a deity; therefore, its meaning cannot be deciphered by any human mind. In fact, the word *Babel* is related to the Hebrew word *bavel,* which is closely allied and probably derived from the Akkadian *babilu* or "gate of God."[8] Even though the librarians in Borges's story attempt to look for the ultimate book, their findings only take them to an incomprehensible amount of information, which leads them to the "gate of God," but not to the understanding of God or its message.

Nowadays, researchers all over the globe work in order to create digital libraries that could contain almost an infinite amount of information in the form of audio, images, and text. Even though these projects, like the Library of Congress's National Digital Library (NDL) and the six projects forming the Digital Library Initiative, have been underway for a long time, they are still far from being complete.[9] Another relevant yet controversial project is Google Print for Libraries, started by the search engine Google with the support of Harvard, Stanford, and the University of Michigan libraries to digitize and make books searchable online.[10] The completion of all these projects seems to be ill-fated not so much because of their technical

impossibilities but rather because of the problems arising from intellectual copyright issues, which turn the projects into almost holy or god-like ventures.

## Rhizomatic Features: From Babylon to the Virtual World

*Babel* is the Hebrew word for Babylon or Babylonia, a city known for the high degree of intellectuality among its people in ancient times as well as for its people's attempt to construct a tower to reach Heaven. Babel's inhabitants spoke one language and, according to the Old Testament, nothing seemed unattainable for them:

> Then the LORD came down to see the city and a tower which mortal men had built, and he said. 'Here they are, one people with a single language,
> and now they have started to do this; henceforward nothing they have in mind to do will be beyond their reach. Come, let us go down there and confuse their speech, so that they will not understand what they say to one another.' So the LORD dispersed them from there all over the earth, and they left off the building of the city. That is why it is called Babel, because the LORD there made a babble of the language of all the world; from that place the LORD scattered men all over the face of the earth. (Gen. 11:5–9)

Borges's "The Library of Babel," takes up the notion of chaos resulting from God's determination to confuse people's languages and communication. The amount of information and confusion in the library is so profound that whatever exists in it can only be comprehended by a god-like mind. "[T]he library is so enormous that any reduction undertaken by humans will be infinitesimal" ("The Library of Babel" 85). Just as people in the biblical episode were unable to communicate after God confused their speech, the people in the library of Babel cannot grasp the meaning of what they find due to the overwhelming amount of information and the intricacies within their own language, even though it is the same language; Borges's point seems to be that a Babel-like confusion already exists in every single language.

At first glance, the Internet and the World Wide Web could be seen as Babel built after a geographic diaspora. This global village is made up of electronic mailing lists, newsgroups of different kinds, and blogs, which bring together people sharing certain interests and ideas. In the same fashion, the great variety of sites posted on the Web seems capable of catering to the needs of almost everyone. It is relatively easy for the people within one group to understand each other. They share their jargon as well as their knowledge, yet the situation gets complicated when people from different groups try to communicate with each other. Why does this happen? The situation could be explained by taking into consideration the structures that

existed in Babylon before and after the Tower of Babel. Before Babel, there was one language system, and it was closed. This language was considered unique and sovereign. The signs within that system had determined everything that could possibly be said. After Babel, words designated a broader set of meanings and pointed to a larger number of signifiers. These words could be equated to Borges's forks in "The Garden of Forking Paths" and to the links in the World Wide Web. The language system opened up to give way to a larger number of systems, many of which were incompatible with one another. After Babel, language acquired a rhizomatic structure, instead of a tree structure governed by hierarchy. Languages broke into rhizomes. There was no longer one language governing the whole structure. According to a rhizomatic theory, "There is no mother tongue, only a power taken over by a dominant language within a political multiplicity" (Deleuze and Guattari 7 ).

If we look at the Tower of Babel from the perspective of Deleuze and Guattari, it is possible to see how language was decentered into other dimensions and registers. The old single language was not abolished; it was assimilated into new languages. Thus, "a language is never closed upon itself, except as a function of impotence" (Deleuze and Guattari 8). The languages in the Tower of Babel multiplied and ceased to have a relation of subject or object. Languages as rhizomes extended in diverse ramified forms. These languages also allowed for the creation of maps. According to the rhizome method, rhizomes make a map and not a trace: "The map is open and connectable in all of its dimensions; it is detachable, reversible, susceptible to constant modification" (Deleuze and Guattari 12). It is all a question of "becomings." Languages, like the books in "The library of Babel" and the World Wide Web, are in a constant state of becoming.

In Genesis, after God disperses man all over the earth, the languages from the Tower of Babel become non-centered, rhizomatic, and non-hierarchical systems. Throughout "The Library of Babel" there is a constant tension between *logos* and *nomos*—striated and smooth surfaces. On the one hand, Borges portrays a library that is total and whose shelves contain all the possible combinations of the twenty-odd orthographic symbols. On the other hand, he presents a library that stretches into past, present, and future due to the interrelation of every book in all books. In spite of this impossibility, there are some gestures towards a rhizomatic structure within the library; Borges, after all, does speak of "the interpolations of every book in all books" ("The Library of Babel" 83). From this perspective, each book resembles a tuber that reaches out and relates to other books, becoming a new work in the process. In this way, Borges's use of words breaks with the

Saussurean binaries and creates words whose meanings open up new and eccentric categories in a smooth space.

It is possible to look at "The Library of Babel" as a rhizomatic structure because, according to Eco, "the abstract model of a net has neither a center nor an outside" (81). By the same token, the library described by Borges is a sphere, and as such, its center is any hexagon and its circumference is inaccessible. Neither the center of the library nor the center of the rhizomatic structure can be found because both are in a constant state of interpolation and becoming. It is impossible to provide a whole description of either of them because readers in a rhizomatic structure, such as the librarians in Borges's story, can only perceive the structure as they move along its striated spaces that have been determined by combination of the fixed number of orthographic symbols.

In Borges's story, the library stands for the universe. This symbolic representation has its foundation in a rhizomatic structure. The library as the universe of human culture resembles what Eco calls a labyrinth of the third type, or net. This library, as the universe, is infinite, because it takes into account multiple interpolations and interpretations. Each book in the library is interpolated with each book of the past, present, or future. Likewise, the universe is likely to receive multiple interpretations by different cultures. Moreover, these interpretations contain everything that has been said and will be said about the universe. Like Borges's library, the universe contains past, present, and future linked through what seems a chaotic network of interpretations. From this perspective, the library of Babel resembles the rhizomatic structure of "The Garden of Forking Paths" and the World Wide Web.

### A Rhizomatic Study of "The Garden of Forking Paths" and the Temporal Struggle between *logos* and *nomos*

"The Garden of Forking Paths" inspires a feeling of freedom and entrapment at the same time. The reader feels free because the author has laid in front of her not just a work of literature but a text that encourages her to behave in an organic and nomadic fashion. Even though the word *garden* signals a type of enclosure and/or closure in the text, its forks and paths provide a sense of transversal movement and multiplicity as the reader attempts to set herself free from the sense of entrapment instigated by the title and materialized in the detective story line of the story.

"The Garden of Forking Paths" is an attempt to create a smooth space in the history of literature. Borges, like other writers and philosophers, was determined to break with the hierarchical authorial power instituted by print

culture. In a constant struggle with the logocentrism of the West, Borges provides a text that moves towards a flight of freedom or smooth space in a print striated context. Borges's desire for an anti-hierarchical text becomes clearer when he states:

> This web of time—the strands of which approach one another, bifurcate, intersect or ignore each other through centuries—embraces *every* possibility. We do not exist in most of them. In some you exist and not I, while in other I do, and you do not, and yet others both of us exist. (100)

Through his writing, Borges grants the reader a choice of paths to take. He also invites the reader to construct new paths in his mind. In so doing, he has decentered literature by breaking down the hierarchical alignment of author and reader. Despite all the possibilities that Borges grants his readers, however, one still must ask whether his allowance of freedom to the reader is sincere. He seems to grant the reader multiple possibilities, yet his texts still have the traits of striated spaces. Even though Borges claims not to be the original writer of his texts, his work still resembles the invention of the great engineer-programmer who has laid out some combinations but has left some open for the reader to figure out. In order to make sense of the puzzles laid out by Borges, the reader needs to explore the forking paths that diverge into multiple stories. This challenging exploration can only be achieved by traversing striated spaces in the process of constructing multiple stories. In Borges's "The Garden of Forking Paths" the garden is a metaphor for the enclosed system of print whereas the forking paths project into infinity, as the rhizome does, making connections and allowing for the possibility of new stories.

While breaking through the striated spaces, the reader of "The Garden of Forking Paths" gets out of the enclosed garden and starts traversing the smooth spaces of the forking paths that push the reader to construct a web of multiple times. Borges's description of the "web of time" in his story resembles the description of the World Wide Web and of the rhizome outlined by Deleuze and Guattari. The paths suggested by Borges bifurcate in every direction, like those in a rhizome. They tend to approach one another, intersect, or ignore each other. Borges's forking paths, like the rhizomes and links of the World Wide Web, are always in a state of becoming. They are organic and extend towards infinity in a constant state of flux. They mark the reader's path in an attempt to exhaust the text. They all refer to time and not to space. It is a common fallacy to associate *forking paths* and the *links* in the World Wide Web with space. What it is necessary is to describe them as Borges does: the *forking paths* are a metaphor for the possibility of alternate

times and stories in the same way that the links in the World Wide Web indicate some of the multiple pathways to take when exploring a docuverse.

There is no real space in the World Wide Web, just as there are no real tangible forking paths in Borges's story. Both are temporal and are a result of a process of association of ideas to construct a story. Both mark an attempt to exhaust the text through an intense exploration of the several possibilities latent in the text. In the World Wide Web, this is achieved by both the possibilities presented and the multiple ideas triggered by those links. In "The Garden of Forking Paths," the reader strives to exhaust the text by mentally constructing a number of outcomes to the story. In short, the World Wide Web, like "The Garden of Forking Paths," relies heavily on the associative power that our minds have to elaborate a web of ideas that generate new paths. Above all, both encourage the reader to traverse a labyrinthine structure in search of the ideal yet impossible smooth environment.

## Rhizome and Hypermedia

The World Wide Web is a non-centered rhizomatic system. Its sites have a rhizome structure composed of links that connect pages to other relevant links creating an almost endless spider-like structure. It is nomadic in nature because it is always in a state of becoming through the innumerable changes that it experiences on a daily basis. Moreover, the World Wide Web, with its multiple entries, allows the reader to join the text in medias res and to navigate in any of the directions established by the marked links or by the new links created by the reader. Systems like the World Wide Web with embedded hypertexts are composed of what Deleuze and Guattari call "smooth surfaces and striated spaces" (489). These two types of spaces do not exist isolated one from the other; on the contrary, they are almost intertwined.

Whereas nomadic smooth spaces represent areas that lack a hierarchical organization, *logos* and authority govern striated spaces. The constant struggle between these two spaces recurs in the World Wide Web when restrictions about access to certain sites limit users' freedom to retrieve or to post information. Even though much has been said about the state of freedom the World Wide Web promotes, only a few, however, have dared to speak about the striated areas of this global system. By striated areas, I mean those spaces that cannot be explored by all the users. In his book *Cybertext* published in 1997, Espen Aarseth states that there are two kinds of users: the "'home owners' and then there is the proletariat, who are read-only consumers without access to the means of Web production" (172). In order to

illustrate his contention, he presents the case of Norway back in 1997, when telecommunication companies offered Internet access without e-mail accounts or disk space for storing personal files. Aarseth believes this state of affairs created a class of "silent surfers" who roamed the World Wide Web docuverse without a voice or a place of their own (172). Thus, the World Wide Web presents in principle a number of characteristics that permit us to define it as a net composed of smooth and striated spaces. The reader of the docuverse is allowed a certain degree of freedom to traverse the text, yet there are a number of trajectories that are latent but have been blocked to some users due to the influence of some hierarchical technological power. Those who are permitted to explore the docuverse with the possibility of designing their own Web pages can create assemblages and connections. They can explore the docuverse in a nomadic fashion. As they move along, they come across conditions of discontinuity, rupture, and multiplicity. There is no absolute smooth space in hypertext. Even those who maintain their own Web sites ascertain a degree of power over those territories because not just anyone is permitted to modify someone else's Web site. The right to modify the Web page belongs to the Webmaster, whose very name, displays a degree of superiority over the "virtual surfers."

In spite of its restrictions, the World Wide Web has also given way to Weblogs or blogs, which represent smooth spaces where people from around the world can interact with other readers, contribute with their comments, and share ideas. Within this framework, blogs have opened up spaces where the public debates on a variety of issues in a space that is not so well controlled by the authority of a Webmaster.

Smooth spaces and striated spaces combined have been more a norm than an exception throughout history. Even though the print medium has been dominated by striated spaces, writers like Joyce, Cortázar, and Borges have attempted to highlight the importance of the reader's role when reconstructing an author's text. They focus on giving the reader the possibility to traverse one or more of a number of multiplicities. In the case of Cortázar's *Hopscotch,* the text provides a striated space marked by the two options given by the author. The smooth space is created once the reader selects one of the two possible reading sequences available to him. In a similar though not identical fashion, Borges's "The Garden of Forking Paths" lays out a combination of striated and smooth spaces whereby the reader is allowed to imagine alternative stories in an attempt to escape from the fictional maze designed by the author. This situation resembles the attitude of the monks in the library of Babel as well as the spirit of those who navigate the World Wide Web in search of meaning.

# Notes

[1] According to Jay Bolter in his book *Writing Space: The Computer, Hypertext and the history of Writing*, Xanadu is a vision for the macrocosm: millions of texts are to be managed and ultimately joined into one world network. The result would be a larger library by far than any ever realized in print or manuscript (Bolter 103). For further reference on Project Xanadu, see note 3.

[2] According to Alvin Kerman in his book *The Death of Literature,* by the eighteenth century reading hade come to be feared in much the same way that too much television viewing in late twentieth century America become a kind of cultural bogey (130).

[3] The phrase *organic textuality* attempts to compare the virtual environment to a living organism which is in a constant state of becoming.

[4] According to Moulthrop, there are various genealogies for this kind of writing, which include Stéphane Mallarmé, Gertrude Stein, and Jorge Luis Borges. He also distinguishes a number of genealogies for hypertext. For a full description of the genealogies, see "No War Machine" at http://www.ubalt.edu/ygcla/sam/war_machine.html.

[5] CERN is the European Laboratory for Particle Physics, the world's largest particle physics center. For further information, refer to http://www.cern.ch/Public/

[6] According to H. S. Venkatagiri, "Speech recognition (SR) is the process whereby a microprocessor-based system, typically a computer with sound processing hardware and speech recognition software, responds in predictable ways to spoken commands and/or converts speech into text." For further reference, see H. S. Venkatagiri "Speech Recognition Technology Applications in Communication Disorders." In the field of olfactory sensing, Cyrano Sciences manufactured a strange scent detection device: "Once trained, this "nose chip" could recognize fragrances it had been exposed to previously and determine when they changed." See Ilan Greenberg, "A Nose for Business" in *MIT Technology Review* July 1999.

[7] This issue of the author and reader reinventing an idea developed by another author is developed in Borges's short story "Pierre Menard: Author of *Don Quixote.*"

[8] For further reference, see Jim A. Cornwell's The Tower of Babel, Babylon, Gilgamesh, Ningizzida, Gudea" at http://www.mazzaroth.com/ChapterThree/TowerOfBabel.htm.

[9] For a more detailed description and an update on the Library of Congress's National Digital Library (NDL) program in the United States and the Digital Library Initiative, refer to http://www.loc.gov/today/pr/2005/05-118.html.

[10] Google Print for Libraries, which was originally launched in December 2004, came to a halt in August 2005 after Google received numerous complaints from publishers and the American Association of Publishers, who claimed that Google violated copyright laws. For an update on the Google Print for Libraries Project, see http://googleblog.blogspot.com/2005/08/making-books-easier-to-find.html.

# Chapter 5

# "The Library of Babel," "The Garden of Forking Paths," and the World Wide Web: Worlds as Mazes and Labyrinthine Nets

## "The Library of Babel" as Labyrinth

Five shelves correspond to each of the walls of each hexagon, each shelf contains thirty-two of a uniform format, each book is made up of four hundred and ten page; each page, of forty lines; each line, of some eighty black letters.

Jorge Luis Borges, "The Library of Babel"

At first glance, there is no doubt that everything within the library of Babel is ruled by *logos*. The detailed description of its shelves, the almost obsessive combination of the twenty-five orthographical signs, and the insatiable search for knowledge by those who roam within its confines reaffirm this assumption. Yet, *logos* and *nomos* coexist in "The Library of Babel." The architectural organization of the library resembles a maze and creates a feeling of entrapment among those who walk through its halls. Its surreal spiral staircase, which projects down into the abyss and rises up into the sky, creates a flight of freedom for those who dare believe in the infinitude of the library based on the interpolations of all books. Thus, it is possible to speak of the two labyrinthine structures of the library of Babel.

From an architectural perspective, the library is a maze, "a Manneristic invention" that can only be seen from within (*Semiotics and the Philosophy of Language* 81). Those who walk in the library of Borges's story to find the perfect book, which contains all answers, can only see a microcosm. The library that they inhabit is infinite in structure. It cannot be understood by any human being because no one can see the whole structure of the library. The only hope is to travel in search of the absolute book. Thus, the librarians of Babel inhabit a maze overpopulated by books. But these books interrelate as a net of knowledge. In this way, the books within the library constitute a labyrinth of the third type: a rhizomatic net.

This endless and ever-growing intertextuality among the books in Borges's library appears as an uncontrollable state of chaos to the human eye. The books in the library of Babel exist and depend on each other for their existence. They are a rhizomatic structure in a constant state of becoming. They are characterized by their everlasting possibility of establishing connections with old, new, and future books. The library exists sempiter-

nally, and it encompasses all the knowledge from the past, present, and future.

The first interpretation of the library of Babel as a maze and rhizomatic structure coincides with the structure Eco developed in *The Name of the Rose*. The Mannerist labyrinth attempts to contain the flight of the rhizomatic labyrinth. In Borges's library, books create a net that is traversed by readers. In Eco's novel, on the other hand, the character William is the one who transverses the rhizomatic space. In reference to this Eco states: "The labyrinth of my library is still a mannerist labyrinth, but the world in which Williams realizes (by the end of the novel) he is living already has a rhizome structure: that is, it can be structured but is never structured definitely" (Postscript to *The Name of the Rose* 526).

Borges and Eco created their stories as literary machines whose meaning and interpretations exceed their own texts. In order to achieve their objectives, Borges and Eco used the metaphor of the labyrinth as a mode of multiple conjectures. In both cases, the rhizomatic labyrinth opens a space for the representation of a metaphysical issue. In Borges's "Library of Babel," the writer confronts the reader with his own limitations as a human being; he discovers the impossibility of understanding a universe ruled by chaos. In Eco's novel, on the other hand, the writer challenges the reader to find multiple meanings in his novel.

Both writers present their texts as war machines that "make war only on condition that they simultaneously create something else" (Deleuze and Guattari 423). *The Name of the Rose* and "The Library of Babel" create spaces whereby the search for multiple meanings becomes the war to be fought, the game to be played. It is a constant process of deterritorializing old spaces and territorializing new ones. Reading these stories requires foresight of the texts' structure and the willingness to exploit the potential of these rhizomatic labyrinths.

## Borges's *Forking Paths* as Constituents of a Labyrinthine Structure

In "The Garden of Forking Paths," Borges refers to "[a]n invisible labyrinth of time" ("The Garden of Forking Paths" 96). Borges's *forking paths* create a labyrinthine structure that attempts to portray the metaphysical possibility of alternate times. From this perspective, it is possible to see the *forking paths* as a rhizomatic labyrinth. This category, as elaborated by Eco in *Semiotics and the Philosophy of Language*, is characterized by a network-like structure where each bifurcation connects itself to another as it extends into infinity. In a meandering structure of this type, "every point can be connected with every other point, and where the connections are yet not designed, they are,

however, conceivable and designable" (81). In "The Garden of Forking Paths," Borges has traced some paths, but the reader is still given the possibility to create more stories or rhizomes. By the same token, a rhizomatic labyrinth of this type is virtually infinite because it gives way to an endless number of projections. This type of labyrinth represents only one plateau of "The Garden of Forking Paths": the metaphorical representation of the possibility of alternate times. The other plateau refers to the detective story per se. As such, "The Garden of Forking Paths" can be seen as what Eco calls a maze. From this point of view, the story displays different alternatives and paths, but only one leads to the way out. Borges, like Eco in his novel *The Name of the Rose*, has combined both labyrinthine structures in his detective story; both Borges's story and Eco's novel have embedded an intertwined structure that contains the rhizomatic labyrinth and the maze.

In order to analyze the role of the rhizomatic labyrinth in Borges's "The Garden of Forking Paths," it is necessary to refer to the terminology used by Deleuze and Guattari in *A Thousand Plateaus*. Having this in mind, it is possible to perceive that in Borges's story the smooth space created by the rhizomatic structure of the encyclopedic labyrinth allows the reader to engage in the design of new paths. This encyclopedic labyrinth, based on the *Encyclopédie* of Diderot and of d'Alembert, makes the rhizomatic structure more tangible, highlighting the importance of human knowledge as a cartographical projection. Each fork created by the reader of "The Garden of Forking Paths" represents a construct, a new alternate time of the story. Since this encyclopedic labyrinth does not have a center, it allows the reader to perceive only a small space and its adjacent areas. Nevertheless, its organic and dynamic essence permits a "transitory system of knowledge" (Eco, *Semiotics and the Philosophy of Language* 87). Instead of having a whole view of the structure, the reader of "The Garden of Forking Paths" finds herself in a rhizomatic encyclopedic labyrinth and embarks on the construction of possible alternate times of the story. The main characters of the story, on the other hand, are trapped within the striated surface of the maze. Stephen Albert's and Yu Tsun's fates have already been determined: "This I proceeded, while with the eyes of a man already dead, I contemplated the fluctuations of the day which would be my last, and watched the diffuse coming of night" ("The Garden of Forking Paths" 93).

These characters' performances comply with the features of a detective story, yet they attempt to create a smooth space for the reader. The numerous references to time as an "ever spreading network of diverging and parallel times" encourage the reader to move out of the contrived striated space into a smooth environment. From this perspective, "The Garden of Forking Paths"

lays out one detective striated plateau while at the same time opening up the gates of a rhizomatic environment by laying out a series of forks in time.

The tension between smooth and striated surfaces in this Borgesian labyrinth implies that the *nomos* has not been able to displace the *logos*. They coexist in the same space, yet they fulfill different functions. The striated space is static, whereas the smooth space is dynamic and nomadic. The *logos* provides a fixed structure, whereas the *nomos* allows for a continuous topological movement. In their constant struggle for independence and power, they generate texts that are locked within certain restrictions but that at the same time encourage a flight of freedom on the part of the reader.

By developing stories that portray the tension between the Western logocentrism and rhizomatic structures, Borges's short stories and Eco's novel foreshadow the present state of affairs illustrated by the World Wide Web. Is humanity once more trapped within the boundaries of the maze, or do new technologies provide forking paths to explore new ways of acquiring knowledge?

## The Labyrinthine World Wide Web and Its Ergodic Nature

> Though so different in style, two writers have offered us an image for the next millennium: Joyce and Borges. The first designed with words what the second designed with ideas: the original, the one and only World Wide Web. The rest will remain simply virtual.
>
> Umberto Eco, *The Future of the Book*

The interpretation of labyrinths has been in a constant state of flux throughout the centuries. Helmut Jaskolski writes that, in their classical form, labyrinths are "geometrical figures with round or square off-exterior boundaries, the lines of which are to be understood as confining walls for paths running between them" (11). This group can be divided into two categories: the Cretan type, which consists of seven convolutions, and the Chartres type, which is an eleven-turn labyrinth with cross-like structure, typical of the church labyrinths of the Middle Ages (11). The modern labyrinth is defined as a maze with a system of multiple paths, some of which lead to a dead end. The third type of labyrinth refers to the one developed by Eco in reference to the metaphor of the rhizome described by Deleuze and Guattari. This rhizomatic labyrinth or net embodies characteristics present in postmodernism. In spite of their differences, all variants of the labyrinth are ergodic in nature. Whoever sets to the task of revealing its mysteries and attempts to make her way out faces the challenging and difficult situation of not being able to see the labyrinth's entire structure.

The World Wide Web is the embodiment of the maze and the rhizomatic labyrinth. Like any labyrinth, this electronic system has a structure determined by the technological possibilities of our times. From this perspective, the whole system is a rhizomatic labyrinth, whereas the Web pages within function as mazes because many of them lack the possibility of being physically expanded by the reader, who often reaches dead ends.

This interpretation provides a very simplistic study of the current state of affairs in technology and literature. In order to provide a sound explanation of the web as a labyrinth that challenges its users to exploit all the embedded features of a hypermedia system, it is necessary to go beyond what the system superficially shows and think of the cues it offers for the development of new ideas and approaches to critical thinking.

In order to understand the unlimited possibilities of the World Wide Web, I prefer to associate the whole system with a rhizomatic labyrinth and look at the possibilities of some of the hyperfiction works within it. The World Wide Web, like a tuber, is in a constant state of development. It expands at an accelerated pace while at the same time the parts within it establish new links with each other, building an intricate net. Even though most hyperfiction, which has been created for the Web, behaves as a closed system because the author has created a number of paths for the reader to traverse, it is up to the reader to exploit the ergodic nature of the text that she assembles, as Aarseth explains: "In ergodic literature, non trivial effort is required to allow the reader to traverse the text" (1). As the reader moves from one node to the other, the text she creates acts as a literary machine that is able to generate a multiple of interpretations or stories. In spite of the fact that in most cases the reader of hyperfiction cannot add new lexias to the text, she is challenged to construct an unlimited number of stories in her mind. From this perspective, it is possible to assert that, whereas most hyperfiction displayed on the Web is still contrived by the technical advances of our times, the present design of most hypertexts allows for a literary analysis of texts that takes into account what the text offers and also the latent structures and possibilities behind the narrative. Within this framework, it is possible to assert that this electronic literature calls for a new way to interpret literary texts. Such an approach should make an attempt to take into account "the other"—that is, all the language and narrative structures that are absently present.

There is no doubt that we are living the preliminary stages of what could be a turning point in the studies of literature and the humanities. Deleuze and Guattari's ideas challenge us to traverse this new stage in a nomadic fashion in order to move forward and establish closer connections between the new

technologies and the humanities. Due to the novelty and possibilities of the new medium, old theories can only help us to trigger new ideas to understand the emerging technologies. Any new type of approach to understanding the literature created in the new medium implies novel ways of thinking about literature.

Before the creation of hypertext and hyperfiction, Borges's works provided the foundation of a new type of reading, one that challenges the striated spaces of literature. From this perspective, Borges's works laid out the foundation for nomadic thought. To read his texts is to embark oneself in the everlasting exploration of the world through language. This process implies the inevitable continuous construction of a rhizome on the part of the reader. Through the reading act the text becomes a net or rhizomatic labyrinth that extends itself as it makes connections to other literary texts.

Within this framework, Borges's "The Garden of Forking Paths" and "The Library of Babel" have been challenging readers and critics to explore the different plateaus and interpolations offered by these works. These fictions, like hyperfictions, immerse readers in the ergodic act of paving their ways out of these literary labyrinths. They push readers to think critically as they move along striated spaces in an attempt to create a smooth space that will give birth to the Other and discover what is not visible to the naked eye. Finally, the new electronic fictions, poems, net art, and video games are characterized by a great number of hidden revelations embedded in complicated and fuzzy environments. The combination of the different media to compose literary works promotes new ways of expression, but at the same time demands new ways of reading and methods of interpretation.

# Chapter 6

# Towards the Future:
# Bridging the Gap between Literature, Science, and Technology

As disciplines move beyond their modern boundaries, they generate ripples in the cultural flow, and these ripples influence the other currents in a nonlinear, random way.

Thomas Weissert, "Borges's Garden of Chaos Dynamics"

## Print, Digital Technology, and Science Converge

The last decade of the twentieth century was marked by the rapid and almost chaotic emergence of technological resources and controversy regarding the importance of technology to the development of human thought. It is hard, almost impossible, to predict to what extent such advances will affect the development of humanistic studies. From the personal computer to the extensive communication networks that seem to extend to infinity, the twentieth century set in motion a number of technological advances that will see their fruition or doom along the coming centuries to come.

There is no doubt that hyperfiction has become one of the new modes of expression. Its malleable structure and rich multimedia environment allow authors and readers to establish new ways to critique and approach the study of narrative. Some hyperfictions help readers to the imagine and visualize metaphysical questions, such as the idea of multiple times developed by Borges in "The Garden of Forking Paths" or the idea of chaos present in "The Library of Babel."

Borges's metaphysical ideas have inspired not only mathematicians and physicists but hyperfiction writers as well. For example, Stuart Moulthrop, with his polyvocal and polytemporal narrative, transcends the here-and-now expressed through a single narrative voice. In the realm of physics and mathematics, Borges's works have helped to the development of modern and postmodern theories. Thomas Weissert has also made this claim in his essay "Borges's Garden of Chaos and Dynamics," where he states that in "'The Garden of Forking Paths' Borges discovered the essence of bifurcation thirty years before chaos scientists mathematically formalized it" (223). Using Weissert's claim as a starting point, it is easy to perceive the relevance of Borges's works within the larger development of bifurcation theory and chaos theory. At the same time, Borges's metaphysical ideas also prefigure many of the literary-scientific considerations present in Stuart Moulthrop's

hyperfiction *Victory Garden* and his cybertext "Reagan Library." With this line of development in mind, I will examine the scientific and Borgesian traces in Moulthrop's *Victory Garden* in order to illustrate the ways in which Moulthrop's digital work embodies the close connection between humanities and the sciences. This approach draws its insights from the scientific theoretical underpinning of concepts such as chaos theory, bifurcation theory, dissipative structures, and noise.

## Metaphorical Use of Scientific Language

Since 1975, advances in chaos theory and a proliferation of technology have influenced literature, challenging writers and readers to expand their modes of expression and interpretation.[1] Thus, in this section I examine Jorge Luis Borges's "The Garden of Forking Paths" (1941) and "The Library of Babel," (1941), not from a Saussurean bipartite point of departure but from the perspective of a tripartite relationship among these texts, chaos theory, and Stuart Moulthrop's *Victory Garden* (1999). I seek to underscore the role played by chaos theory, bifurcation theory, dissipative structures, complex systems, and noise as points of convergence in these works. The dialogue among these texts separates this analysis from earlier studies. The modeling of this new perspective in the study of "The Garden of Forking Paths," "The Library of Babel," and *Victory Garden* opens up a space for exploring Borges's work with reference to the constant evolution and points of contact among literature, science, and digital narratives. The modeling of this new perspective in the study of "The Garden of Forking Paths," "The Library of Babel," and *Victory Garden* opens up a space for exploring Borges's work with reference to the constant evolution and points of contact among literature, science, and digital narratives.

## Bipartite Analyses: Borges-Chaos/Borges-Hypertext

Among others, Ana María Barrenechea, Michael Capobianco, Antonio Pineda Cachero, Thomas Weissert, Gabriel Schreiber, Roberto Umansky, Stuart Moulthrop, and Jay David Bolter have articulated the bipartite relationship between Borges's work and chaos or the relationship between Borges's texts and hypertext. Their critique lays the foundation for the exploration of the tripartite relationship among literature, science, and technology as presented in this analysis.

Ana María Barrenechea's *Borges: The Labyrinth Maker* (1965) marked the beginning of a new approach to Borges's work. In her chapter "Chaos and the Cosmos," Barrenechea acknowledges Borges's preoccupation with the concept of chaos and his unique ways of representing it. In Barrenechea's

words, "Borges presents the concept of a chaotic and illusory world by means of a few lucid details and a narrative structure that is well planned and coherent. Disorder, on the other hand, takes root in the occurrences to which he refers, in certain coined symbols, and in a sector of his vocabulary" (51). After Barrenechea, a growing body of scholarship has examined Borges's "The Garden of Forking Paths" with reference to chaos theory and complex systems.

In his article "Quantum Theory, Spacetime and Borges's Bifurcations," Michael F. Capobianco observes that "The Garden of Forking Paths" presents the space-time diagram from modern physics as an element of the internal structure of the short story (27). Thomas Weissert, by contrast, claims that "The Garden of Forking Paths" belongs to a historical period of transition from a post-Newtonian to a postmodernist understanding of the universe. To illustrate his point, Weissert examines the levels of reality in "The Garden of Forking Paths" and the levels of reality in dynamics. By way of "correlating these levels of reality for a specific case," Weissert shows "how science and literature work as consensual constructions" (225).

Four decades after the publication of *Borges: The Labyrinth Maker,* the subject of chaos and complexity in "The Garden of Forking Paths" continues to fascinate critics. Several have developed the topic as a metaphorical bifurcation of previous critical work. Antonio Pineda Cachero's essay is an excellent example of this trend. He describes "The Garden of Forking Paths" as a neofantastic story that embeds Ilya Prigogine's concept of the irreversibility of time as described in *Las leyes del caos.* Pineda Cachero explores the intricate connection between the genre that he defines as neofantastic and the place occupied by Borges in a new postulation of reality where art, culture, and science overlap.[2]

In their essay "Bifurcation, Chaos, and Fractal Objects in Borges' 'Garden of Forking Paths' and Other Writings," Gabriel Schreiber and Roberto Umansky further discuss the connection between bifurcations and "The Garden of Forking Paths." The authors flesh out the idea that in this story, "Borges prefers to deal with bifurcations, chaotic aspects involving time, rather than with fractal geometry involving space" (65).

With the emergence of digital writing, this image of bifurcations has become particularly appealing to hypertext authors and critics who see hyperfiction as an ideal tool to describe Borges's scientific and metaphysical concerns. "The Garden of Forking Paths" has inspired many hyperfiction writers and critics, many of whom have found in Borges's works metaphysical and scientific ideas that relate to the emerging paradigms of hyperfiction. Stuart Moulthrop's article "Reading from the Map: Metonymy

and Metaphor in the Fiction of Forking Paths," is one of the first to focus on Borges's work through the lenses of hypermedia (118). In this groundbreaking essay, Moulthrop notes that the literary affiliations of hypertextual fiction can be traced to contemporary experimentalists, theorists, modernists, or even to an older tradition of narrative eccentricity. However, he notes that "none goes as far toward defining the issues at stake in narrative hypertext as does a sequence of short stories that appeared in the early forties: Jorge Luis Borges' 'Garden of Forking Paths'" (118). Moulthrop's claim is informed by his reflections upon Borgesian thought, hypertext, and literary theory. These overlapping fields are also apparent in Moulthrop's pieces "forking paths" (1987), *Victory Garden* (1991), "Heriscope" (1995–1997), and "Reagan Library" (1999).

Jay Bolter has also noted that in "The Garden of Forking Paths," the garden "suggests a luxuriant growth of textual possibilities" (139). Bolter also acknowledges that Borges's prefiguring of the possibility of multiple temporalities belongs "in another writing space altogether" (139). This space is the digital environment where literature and science interact, providing new ways of representation and interpretation. Bolter's claim is justified by Borges's characters. Stephen Albert, the famous Sinologist who explains the concept of bifurcating times, states: "Time is forever dividing itself towards innumerable futures and in one of them I am your enemy" ("The Garden of Forking Paths" 100).

## Borges's Metaphysical Worlds

Jorge Luis Borges's labyrinthine fictional pieces take the reader beyond the perfect plot to a new realm where storytelling, philosophy, and science converge. Fantasy and reality seem to blur, and the reader is left to her own devices to figure out the author's subliminal metaphysical postulates, such as the possibility of simultaneous times. For example, in "The Garden of Forking Paths," reality and fantasy overlap as Yu Tsun ponders upon the ideas implied in his ancestor's novel: "...I sensed the pullulation of which I have already spoken. It seemed to me that the dew-damp garden surrounding the house was infinitely saturated with invisible people. All were Albert and myself, secretive, busy and multiform in other dimensions of time. I lifted my eyes and the short nightmare disappeared" ("The Garden of Forking Paths" 101). Borges relies on a succinct narrative frame to encrypt his philosophical interests. Michael Holquist refers to "The Garden of Forking Paths" as a "metaphysical detective story" whose plot raises questions from the lexical and narrative levels (93). The novel of Yu Tsun's ancestor provides the clues for a new interpretation of time and the world, as expressed by Dr. Stephen Albert: "*The*

*Garden of Forking Paths* is an enormous guessing game, or parable, in which the subject is time. The rules of the game forbid the use of the word itself. To eliminate a word completely, to refer to it by means of inept phrases and obvious phrases, is perhaps the best way of drawing attention to it" ("The Garden of Forking Paths" 99–100).

In "The Garden of Forking Paths" and "The Library of Babel," Borges uses scientific tropes to express philosophical concepts, and thus anticipates scientific views that were to become the focus of debate in the late 1950s. In his essay "Borges's Garden of Chaos Dynamics," Weissert declares that in "'The Garden of Forking Paths' Borges discovered the essence of Bifurcation Theory thirty years before chaos scientists mathematically formalized it" (223). Throughout this Kafkian metaphysical detective story, Borges not only conveys the possibility of multiple times but also foreshadows the many-worlds interpretation that was first proposed in 1957 by Hugh Everett II.[3] Stephen Albert's voice once again expresses Borges's fantastic, innovative, yet disturbing picture of the world: "The *Garden of Forking Paths* is a picture, incomplete yet not false, of the universe as Ts'ui Pên conceived it to be. Differing from Newton and Schopenhauer, your ancestor did not think of time as absolute and uniform. He believed in an infinite series of times, in a dizzily growing ever spreading network of diverging and converging and parallel times" ("The Garden of Forking Paths" 100).

Another hypothesis that Borges introduces in "The Garden of Forking Paths" is the idea of "order out of chaos" as elaborated by Ilya Prigogine and Isabelle Stengers in *Order Out of Chaos la Nouvelle Alliance* (1979). To illustrate the idea of 'orderly chaos,' Borges immerses the reader in fantastic worlds where perfection and chaos coexist. Donald Leslie Shaw has demonstrated that in "The Garden of Forking Paths" the labyrinths stand for "man made realities that though bafflingly chaotic, have an appearance of regularity and order" and that the same concept is "visible in the order, containing chaos, of the Library of Babel" (42). It is through these short stories that Borges ponders the turbulent changes that took place in Argentina throughout the late 1930s and 1940s, a time marked by an 18 month military coup that "was the opening shot in what was to become, according to Gene Bell-Villada, a new, chaotic, completely unresolved Argentina—the one we know today" (21). José Felix Uriburu's military coup awakened strong nationalistic and oligarchic feelings while dissolving the legislature and turning the dictator into an almost mythological figure. Because of these events, Borges abandons his nationalistic perspective and adopts a more universal and philosophical approach in his writing. Thereafter, he uses his narrative "as another strategy for establishing an order in a society where old orders, precisely, were vanish-

ing."[4] Borges deploys his new strategy in the "The Garden of Forking Paths" and in "The Library of Babel." Whereas the former refers to the events of World War I and the interpretation of a chaotic manuscript, the latter alludes to a symmetrical library whose dwellers engage in a frantic quest for meaning as they try to understand the chaotic nature of its artifacts. To highlight the contrast between a structured environment and inhabitants frustrated in their search for meaning and identity, Borges states: "It is now four centuries since men have been wearing these hexagons" ("The Library of Babel" 84).

### War Narratives-Chaotic Environments: From Text to Hypertext

Even though "The Garden of Forking Paths," "The Library of Babel," and *Victory Garden* (1991) were created at different times in different media, a reading of each text through the lenses of chaos theory and technology illuminates the other. These literary artifacts share a number of traits that the avid Borges reader cannot overlook; among them, theme, structure, and references to chaos theory and bifurcation theory. Whereas "The Garden of Forking Paths" and *Victory Garden* incorporate confusion and chaos of a time of war, "The Library of Babel," with its symmetrical, almost infinite structure and its unintelligible artifacts, dares the reader to make sense of an orderly chaotic environment that incorporates confusion to underscore man's frantic search for his own destiny.

Borges and Moulthrop rely on discourses that mask their common interests in man's destiny and in scientific and technological developments. For example, the first paragraph of "The Garden of Forking Paths" introduces readers to events of World War I in which the British artillery defensive attack against the Germans "scheduled for July 24th, 1916" was postponed ("The Garden of Forking Paths" 89). As the plot develops, Yu Tsun, the main character, faces a double objective. On the one hand, he must relay a secret to the British artillery. On the other hand, he feels compelled to understand his ancestor's legacy: a labyrinth and a chaotic novel. As he reflects on his ancestor's labyrinth, Yu Tsun thinks of "a maze of mazes, of a sinuous, ever growing maze which would take in both past and future" ("The Garden of Forking Paths" 94). *Victory Garden* echoes Borges's war narrative: "I am trying to get some reading done (story of my life) but the world keeps intruding. It is 7:05 p.m. on the 16th of January, 1991. Something dark and terrible is unfolding in Baghdad, Iraq. Something dark and terrible took place in Staffordshire, England during the month of July, 1916....At the moment, none of these events seem real" ("Story of My Life").[5] Moulthrop's hypertext takes up the war theme by narrating events of the Gulf War within an environment that underscores late twentieth-century

technology to present a Borgesian text and ideas from a new perspective. In one of the lexias, Moulthrop states:

> Maybe history *is* different for us. Perhaps hypermediated and postmodernized, we now live in a universe that looks suspiciously like a Garden of Forking Paths. Or perhaps the old ways of understanding our lives—struggle, question, commitment, love, loss, mourning—can't really be pushed aside. I did not set out to resolve that issue. I set out to put some stories in motion, hoping they'd take me somewhere. Here's where they led..." ("The Place of the Big Wind")

In "The Library of Babel," the reader, like a detective in a time of war, must decipher the secret message encoded in the narrative. The librarians' search for meaning stands for man's quest for his own destiny in a library which is described by some as "the febrile Library, whose hazardous volumes...run the constant risk of being changed into others and in which everything is affirmed, denied, and confused by a divinity in delirium" ("The Library of Babel" 86). Borges's frantic and unstable library speaks to and illuminates the unpredictable, chaotic, and war-like scenarios in "The Garden of Forking Paths" and *Victory Garden,* where an unexpected event could determine a new outcome in the story. Consequently, the ludic aspect of "The Garden of Forking Paths," "The Library of Babel," and *Victory Garden* lies in their ability to yield new ideas and challenge readers to focus on the reading process as they generate new interpretations and figure out what these two stories stand for.

Borges's texts and Moulthrop's stories are *works that yield:* a phrase that I coin and that refers back to Michael Joyce's definition of "words that yield."[6] Thus, taking up Joyce's interpretation of a lexia as an anchor that generates more text and therefore more understanding of a hypertext, I see these three literary works as generating a new understanding of literature. By traversing and assembling these texts, the reader moves beyond the plot to come to terms with the metaphorical implications of the texts that are signaled by metaphysical, scientific, and technological references. These literary texts and the relationships that can be established among them allow us to see them as complex artifacts portraying the complexities of a world as defined by chaos theory and complex systems.

### Chaos: Structure and Meaning

"The Garden of Forking Paths," "The Library of Babel," and *Victory Garden* are amenable to an analysis based on modern chaos theory. With respect to chaos theory, Katherine Hayles notes that "a: "At the center of chaos theory is the discovery that hidden within the unpredictability of chaotic systems are

deep structures of order. 'Chaos,' in this usage, denotes not true randomness, but the disorder characteristic of these systems" (*Chaos and Order* 1). "The Garden of Forking Paths" and *Victory Garden* illustrate Hayles's claim because these two highly structured narratives display chaotic environments. For example, in "The Garden of Forking Paths," which is a spy/detective story, Yu Tsun, great-grandson of Ts'ui Pên, finds himself trapped in a Borgesian labyrinth as he tries to decipher his ancestor's incomprehensible manuscript. While trying to convey a secret coded message in a time of war, Yu Tsun faces the challenge of comprehending his ancestor's likewise secret coded text. The concept of meaning out of chaos becomes tangible when Stephen Albert explains to Yu Tsun that the labyrinth and the novel that his ancestor created are not distinct objects but one and the same: "At one time, Ts'ui Pên must have said; "I am going into seclusion to write a book,' and at another, 'I am retiring to construct a maze.' Everyone assumed these were separate activities. No one realized that the book and the labyrinth were one and the same" ("The Garden of Forking Paths" 96). The reader is left to apply "chaotic" reasoning to extract meaning from Yu Tsun's apparently random murder of Stephen Albert, and from the short narrative that they inhabit. The act of reading becomes an act of spying, of playing detective, and of making meaning in a multilayered maze.

In *Victory Garden,* on the other hand, the author has set—by means of a computer program with cascading binaries—certain restrictions or paths that the reader can explore. Even though *Victory Garden* provides the reader with some predetermined narrative possibilities, this hyperfiction encourages her to form new connections among the different narrative threads. As the reader processes different readings, initial chaos and disorder simultaneously become important elements for understanding each individual narrative. Thus, the reading process resembles one of assemblage, whereby the reader tries to piece together how the different narrative threads and/or lexias supplement each other. This concept is illustrated by two consecutive lexias from *Victory Garden,* one of which presents a reflection on a television broadcast, while the other reveals a character's opinion on the Gulf War:

> Thursday night, January 16, 1991. Here is what the war looks like so far: Blowtorch flares from F-15 Strikes Eagles burning above a "large airbase somewhere in Saudi Arabia...." ...Street maps of downtown Baghdad with an ID shot of Holliman, Amett or Shaw stuck on...Peter Jennings automaton avunculus, looking like he could use a few more minutes on the nod, which makes him *almost human"* ("Images"). "You have to believe, you've gotta have faith," Thea pointed out. "This isn't going to be any television war, sister. It's not what you see that matters, but what you don't see. Press restrictions, pool coverage, censorship. ("Unseen")

By combining data from the different narrations, different readers are likely to reach varying degrees of closure and a better understanding of this body of text and its metaphysical implications.

This strategy is announced in one of the lexias of *Victory Garden* that resembles a news broadcast. The reader is informed: "It's a familiar feast, all fragments and repetition stuck together with a paste of groundless spec. And of course it's what we do not see that counts" ("Images"). Readers are therefore reminded to pay attention to what is not being said in each "story." In "The Garden of Forking Paths," Ts'ui Pên's writing relies on an identical strategy. Ts'ui Pên subtlety omits the word time in his novel. In Borges's and Moulthrop's texts, reality and the main issues of their work exist as an absence, as a voice that is silent and waits to be found among the surrounding chaos.

In "The Garden of Forking Paths" and in *Victory Garden*, Borges and Moulthrop predetermine the possibility or even the necessity of finding meaning in their stories; stories that illustrate the concept of orderly disorder.[7] The reader is provided with basic structural and linguistic elements that allow her to create and/or recreate the stories in varying levels depending still on motivation and circumstances. This approach embraces literature as a complex system in a constant state of transformation influenced by the active reader and her environment.

### Bifurcation Theory and Dissipative Structures

"The Garden of Forking Paths," "The Library of Babel," and *Victory Garden* illustrate bifurcation theory and dissipative structures. These concepts refer to multiple chronologies and create narratives that challenge the characters as they strive to survive and make sense of the complex and chaotic systems in which they (and the reader) are immersed. In the foreword to Prigogine and Stengers's *Order Out of Chaos: Man's Dialogue with Nature*, Alvin Toffler states:

> In Prigoginian terms, all systems contain subsystems which are continually 'fluctuating.' At times, a single fluctuation or a combination of them may become so powerful, as a result of positive feedback, that it shatters the pre-existing organization. At this revolutionary moment—the authors call it a 'singular moment' or a 'bifurcation point'—it is inherently impossible to determine in advance which direction change will take: whether the system will disintegrate into 'chaos' or leap to a new, more differentiated, higher level of 'order' or organization they call a 'dissipative structure. ' (xv)

These stabilizing forces, called dissipative structures, therefore result from a quest for organization and equilibrium within a system. They are markers of

transformative points at which the narrative changes to yield a more coherent, harmonious, and meaningful environment within the system. In effect, the system/narrative branches off, creating a number of possibilities and solutions that emerge not only from the interactions within the system, but also from its unique prior development.

The concept of "dissipative structures" provides a new interpretation of the world that is based on a constant process of being and becoming. Throughout this transformation and evolution, systems evolve from a disorderly state into a reorganized environment. In his essay "Literature as Dissipative Structure," David Porush explains that Prigogine's work provides us with "the tools to understand and justify features of the literary discourse that are otherwise hard to explain from a scientific perspective" (283). Among the features Porush mentions in his essay are the complexity of literary discourse, or "its unique ability to excite the imagination, its sense of nondeterministic, unpredictable complexity and organization as well as its narrative of the unruly and chaotic as the grounds for higher insights" (283). "The Library of Babel," "The Garden of Forking Paths," and *Victory Garden* embody the concept of dissipative structures by allowing readers to go beyond a bipartite Saussurean interpretation of the texts and making possible the emergence of multiple plots that evolve as the reader gains a better understanding of complex texts and the relationships among them.

## Bifurcations

One interesting approach to bifurcation theory is outlined by John Briggs and David Peat in *Turbulent Mirror,* where they discuss the applicability of bifurcation theory to the creative process. In their words, "in experiencing nuance we enter the borderline between order and chaos" (195). Briggs and Peat assert that whereas many of us either fail to recognize such nuances or purposefully deny them because they "threaten our customary thinking," those with a creative mind focus on these disturbing elements to "permit something new to bloom" (195). According to Briggs and Peat, this process allows "the material being worked with…to bifurcate to new planes of reference, and to form feedback loops among different planes in a process which self-organizes a form to embody the nuance" (195).

"The Garden of Forking Paths," "The Library of Babel," and *Victory Garden* force the reader to search for meaning out of chaos by carefully engaging in nontraditional readings to seek clues that will help her understand the ideas veiled behind these texts. For example in "The Library of Babel," the reader is challenged to see the library in at least three ways: as a metaphor for the universe, as a reference to Argentina's dictatorial political

structure and its chaotic social environment, and as the place where man tirelessly searches for his destiny. These multiple interpretations oblige the reader to constantly recreate the text and to engage in thinking that, taking up on Briggs's and Peat's position, "bifurcates to new planes of reference" (195). Bifurcation theory is particularly productive in establishing points of convergence and divergence between "The Garden of Forking Paths," "The Library of Babel," and *Victory Garden* as parts of a single complex system, within which the three works engage in an intertextual dialogue: each text illuminates the others and strengthens the message each conveys. As in a bifurcation point, the three works converge in a thematic point—the existence of a fundamental orderly structure under a narrative that at first glance disorients the reader. Moulthrop's digital work materializes this concept in a carefully planned structure embedded with Borgesian references. At the same time, Borges's works speak to Moulthrop's text as inspirational pieces whose metaphorical themes are taken to the digital realm. Nevertheless, each of the texts diverges in a new direction, conveying its message in a unique fashion. "The Library of Babel" illustrates man's quest to find some equilibrium in his search for destiny and situates the narrator in a remote time and unspecified location, adding universality to the story. "The Garden of Forking Paths" and *Victory Garden* immerse the reader in two wars where characters and readers alike try to make sense of a chaotic environment.

Writing about "The Garden of Forking Paths," Weissert claims that "an essential characteristic of bifurcations in nonlinear physical systems is that, at the splitting, chance determines which path the system will take" (234). Borges anticipates Briggs and Peat by acknowledging the role of chance and choice: "Sometimes the pathways of this labyrinth converge. For example, you come to this house, but in other possible pasts you are my enemy, in others my friend" ("The Garden of Forking Paths" 98). Another metaphorical reference to bifurcations is embedded in the story's dual narratives, which branch off in two different directions: a detective story and a philosophical exploration that in itself anticipates bifurcation theory. Stephen Albert's words illustrate this point: "...'I leave to various future times, but not to all, my garden of forking paths.' I had no sooner read this, that I understood, *The Garden of Forking Paths* was the chaotic novel itself. The phrase 'to various times, but not all,' suggested the image of bifurcating in time, not in space" ("The Garden of Forking Paths" 97–98). Similarly, Moulthrop takes up Borges's strategy in *Victory Garden,* where he conveys bifurcations by allowing the reader to select the lexias and reading paths she wants to traverse. In the introduction to *Victory Garden,* Moulthop informs the reader:

"At most moments you can also double-click certain words ('words that yield') which will take you to a different story line. Though yield-words often create discontinuities, they also map connections" ("Welcome").

Moulthrop recreates Borges's multiple pasts, presents, and futures and adds another layer of complexity by restructuring the linear narrative with technology. In *Victory Garden,* the bifurcations of modern chaos theory and the metaphor of multiple times are presented through a set of binary constraints.[8] According to Stuart Moulthrop, "...the reading paths do change according to a set of binary constraints (often multiple, cascading binaries), and this effect makes it unlikely that a second reading will resemble a first reading. As well, there are mechanisms that are meant to seduce the reader into establishing a different set of initial conditions and thus discovering new paths through the text" (e-mail to the author). This bifurcating structure and its language intentionally engage the reader into creating multiple worlds. The choices the reader makes during the reading lead to bifurcating points at which the storyline shifts in time and in place.

One of the multiple readings of *Victory Garden* starts with a class in progress, discussing Borges's ideas, followed by what seems an almost unrelated passage where Professor Dorothea Agnew and a young student named Veronica acknowledge the relevance and reality of the Gulf War. To Veronica the war feels unimaginable: "For the second time tonight the same thought seized her. 'It can't be real. This is the end of the 20th century. War is something you study in history classes'" ("Unreal"). As happens in Borges's "The Garden of Forking Paths," reality and fantasy merge in *Victory Garden* adding a surrealistic tone to the narrative.

As the reader continues, the story bifurcates to a description of Dr. Urquhart's experiment related to dreams and the unconscious to be followed by quotations concerning literary theory and technology by critics such as Roland Barthes, Donna Haraway, and Gregory Ulmer. Ulmer's words reflect the impact of media in our daily lives: "Everything now, in its own way, wants to be television—Greg Ulmer, *Teletheory*" ("Wannabe"). All these segments are followed by a lexia that takes the reader to the scene where Emily Runbird, Veronica's sister and Professor Agnew's student, has been deployed to the war as a combat postal clerk and is now in a very real, frightening, and chaotic battlefield. This highly wrought structure of *Victory Garden* makes tangible the underlying concepts of bifurcation and chaos theory because it illustrates multiple plots and it relies on creating meaning out of apparent chaos. Each bifurcation generates a new narrative thread causing the perpetually evolving system to be reorganized as with the emergence of a dissipative structure.

Although *Victory Garden* has many intertwined levels or stories, these are not hierarchical layers; rather, they are but narrative threads that supplement each other and contribute to the reader's understanding. By interpolating references to developments in chaos theory and technology in his narrative, Moulthrop signals a new interpretation of the world and of literature: "There are no patterns here, no true correspondences. The world cannot be understood in terms of providence, fate, tragedy, spatial form. The world is only a complex problem in nonlinear dynamics, the ultimate chaos experiment" ("Anonymous"). Hence, *Victory Garden* invites the reader to see the literary work of Borges from a new perspective that engages the reader in a new interpretation as if it were a natural bifurcation of Moulthrop's digital work.

## Dissipative Structures

As stated earlier, "The Garden of Forking Paths" and "The Library of Babel" contain elements that seem to obey laws similar to the ones observed by dissipative structures. For example, the characters in these stories engage in a search for meaning that goes beyond the binary signifier/signified interpretation of the text. To make sense of the situation in which they find themselves, Yu Tsun and those who inhabit Borges's library of Babel must understand the texts before them as "open rather than sterile and self referential systems of signs, reliant upon input from other sources to make them go and on a process of dissipating entropy (analogous to interpretation) to make them grow" (Porush 301). Similarly, the readers of the two stories must consider multiple and confusing levels of meaning—referential, metaphoric, symbolic, and perhaps even historical references—in order to achieve varying degrees of understanding and overlapping issues in both works.

Whereas Borges's texts present some of the features of dissipative structures, they also trigger in their readers cognitive strategies that resemble some of the features of dissipative structures. Porush observes that "even the moment of insight to which great texts bring us can be viewed as an explosively meaningful reorganization and addition of information in the reader's mind, much like the activity of a dissipative structure" (295–296). This is evident in Borges's "The Garden of Forking Paths" and "The Library of Babel," in which readers and characters of these stories must invest a considerable amount of time and cognitive effort to reorganize their thinking to make sense of the complex and chaotic information presented to them. Characters and readers alike are challenged to deal with a subtle portrayal of metaphysical implications and scientific and cultural challenges.

Similarly, as the narrative of *Victory Garden* unfolds, the reader encounters references to multiple times and realities. Key among these is the reference to Professor Urquhart, who is working on a research project related to virtual reality and who has included in his students' reading assignment "The Garden of Forking Paths." There is no doubt that Urquhart's voice raises and reiterates the issue of multiple times and chronologies laid out by Borges in his story. Through a conversation between Thea Agnew, another professor, and Urquhart, the reader finds out that Urquhart's desire for change in the world goes hand in hand with his interest as a scientist. A haphazard selection of links directs the reader to a somewhat surreal passage in which Professor Urquhart explains his experiment with interactive electronics and "Alternate Realities" ("Just Say No"). According to Urquhart, he and his team "are attempting to locate and stimulate the mental faculties that allow us to perceive the world not as a singular, linear unfolding, not a closed system or a line of necessity, but rather as a network of possibilities, an organicity of intersections, parallels and departures, infinite in its extension and vast possibilities of permutations" ("Vox-Pop"). Urquhart's research agenda echoes Porush's claim that "the notion that the human mind—or at least its information processing capacities—is itself as a dissipative structure is not far fetched as it may sound" (305). Porush concludes that "very recent theories of neural action, and its integration into the general schema of biological development and human behavior, suggest that these activities operate according to 'central mathematical concepts of self-organization in non-equilibrium systems'" (305). Urquhart's "scientific" approach links *Victory Garden* back to Borges's fiction and his experiment invites readers to consider bifurcation theory and the presence of dissipative structures as means to reexamine Borges's short stories. Moulthrop, like Borges, invites readers to reassess their traditional rules for interpretation of reality to generate meaning out of complex systems that abound with noise, redundancy, and confusion.

## Noise

The term *noise,* commonly associated with interruption or poor quality of transmission, has its origins in early radio broadcasts, which were often affected by atmospheric changes and gave way to jamming and distortion. Real noise is created not only by the presence of an external element that interferes with the transmission but also by the internal components of the system that affect the transmission of a code. I concur with William R. Paulson's claim that "under the right circumstances, noise—from whatever source—can create complexity, can *augment* the total information of a

system" (73). One of the examples of noise cited by Paulson in *The Noise of Culture* is Borges's library of Babel, where the lack of codes for understanding random symbols "does not stop the librarians from pursuing their searches for the pockets of intelligibility that many believe must be there somewhere" (77). Paulson explains that "the poetic text begins as an attempt to go beyond the usual system of a language—in which the world is a conventional sign—to a specifically artistic system, in which sounds, rhythms and positional relations between elements will signify in new ways " (85–86). Likewise, in "The Garden of Forking Paths" the spy/detective plot and the decipherment of Ts'ui Pên's manuscript are intertwined in such a manner as to obscure Yu Tsun's role as a spy for the Germans. Each narrative thread forces the reader to change focus as she gathers clues to understand the characters' true motivations and the very unexpected narratives. Yu Tsun's words illustrate the change of focus as he momentarily puts his war mission momentarily on hold to come to terms with his ancestor's writing: "I calculated that my pursuer, Richard Madden, could not arrive in less than an hour. My irrevocable decision could wait" ("The Garden of Forking Paths" 95). As the narrative progresses, the reader must identify and decode an abundant quantity of apparently incoherent data as clues to understand the story. Likewise, Yu Tsun chooses Stephen Albert for reasons unrelated to his ancestor, yet his murder victim surprisingly leads them to Ts'ui Pên's manuscript. Equivocal noisy clues, characterized by statements that provide a combination of real and metaphysical information, underscore the reader's fundamental role in transforming noise into message.

The reader's relevance in translating noise into message also conforms to Jurij Lotman's application of the term "noise" to the arts. Paulson notes that "in Lotman's view, the artistic text arises when its reader encounters elements for which the ordinary codes of language possessed by him are not adequate, elements, in other words, which are foreign to his reading process as determinism, as reception of signs according to rules already possessed" (89). Paulson elaborates on Lotman's observation by noting two possible stances vis-à-vis noise and confusion. On the one hand, he refers to the unadaptive reader, one who is incapable of adapting and/or learning new codes. The unadaptive reader struggles with the code and what she considers noise disrupts the reading process. On the other hand, there is the adaptive reader, who is capable of deriving meaning and who "assumes the task of integrating elements that ordinary codes of reading do not account for" (90). This is the type of reader that both Borges and Moulthrop have in mind for their texts. Such a reader who assumes as input not only the codes she understands but also the interpretation she has made of the disruptive elements of the text.

Borges expresses a straightforward and unsettling challenge to the reader in "The Library of Babel": "You who read me are you sure you understand my language?" (87). In a similar way, in *Victory Garden* Moulthrop invites the reader to seek meaning through noise, as in a lexia entitled "Enigma:" "Like any maze or enigma, *Victory Garden* will bring you back to a place you've already been. Sometimes these familiar moments will be followed by something new. At other times you might find yourself in a loop, in which case, you might want to invoke a yield-word" ("Enigma"). It is this traveling back and forth in time through the different narratives that creates noise and confusion in the unraveling of the stories and their metaphorical implications.

In *Victory Garden,* the reader has no other option but to consider noise and redundancy as a supplement necessary for the reading/decoding process. As she moves through the different layers of the story, she is compelled to perform what Paulson describes as: "constructing an autonomous explanation of how the lower level is integrated into the overall system" (110). *Victory Garden* engages readers in a challenging process of mapping whereby structure, narrative, and meaning are intricately related. This understanding is crucial for comprehending the connection between *Victory Garden* and the Borgesian fiction with which it shares a close, intertextual relationship.

## Conclusion

Throughout this chapter I have engaged "The Garden of Forking Paths," "The Library of Babel," and *Victory Garden* in a mutual dialogue as artifacts that belong to a complex system. In this view, each text speaks to the others via a common code embodied in the references to chaos theory, bifurcations, dissipative structures, and noise. As new meanings emerge through the dialogical loop among these three literary pieces, the reader becomes more aware of the intricate connections among Borges's works, hyperfiction, and science.

Whereas "The Garden of Forking Paths" and "The Library of Babel" metaphorically foreshadow a narrative similar to the scientific model of chaos and bifurcation theories devised by scientists, *Victory Garden* retrospectively materializes Borges's ideas, as well as his mathematical and metaphysical concerns, thus bridging the gap between scientific and literary discourses. Similarly, the ideas emerging from chaos and bifurcation theory, dissipative structures, noise, and science illuminate Borges's and Moulthop's work and underscore their points of convergence and divergence.

The reciprocal interconnectedness of Borges's stories, *Victory Garden,* scientific theory, and technology once more acknowledges the intricate connections among print literature, digital literature, and science. Further, it

suggests a first step toward a new interpretation of Borges's oeuvre: a perspective that reaffirms his significant role in Latin American letters while acknowledging its projection into what seems an ever-evolving digital realm.

## Notes

[1] On the coinage of the term *chaos,* see Li and Yorke 985.

[2] For further reference see "Literatura, Comunicación y Caos: Una lectura de Jorge Luis Borges" at http://www.cica.es/aliens/gittcus/700pineda.html.

[3] For further reference and Borges's definition of a "Kafkian fiction," see Sarlo, "Borges, a Writer on the Edge."

[4] Ibid.

[5] I cite *Victory Garden* by stating the title of the node to which I refer.

[6] For further explanation on Michael Joyce's "words that yield," see Larsen and Higgason.

[7] For an interpretation of the concept "orderly disorderly" in Spanish literature, see Williamsen.

[8] On the types of choices a reader has while reading a hyperfiction created with Storyspace, see Rettberg.

# Chaosmic Libraries: Jorge Luis Borges's "The Library of Babel" and Stuart Moulthrop's Cybertext "Reagan Library"

As a natural bifurcation of the previous discussion, this chapter explores the tripartite connection among "The Library of Babel," Moulthrop's cybertext "Reagan Library," and chaos theory. Each element of this triad contributes to the understanding of each literary work from the perspective of science and digital technology. In doing so, these two metachaotic texts speak to each other, thus presenting a new perspective that considers them as part of a complex system where texts interact with each other, triggering new interpretations.

According to Susana Pajares Tosca, "hypertext fiction generally plays with disorientation as an aesthetic effect" and "each hyperfiction has its own reading rules embedded in its structure, and they apply often only to that text" (271). This same idea of disorientation, which is almost innate in "Reagan Library" is also obvious in Borges's "The Library of Babel," where the symmetrical architecture and almost perfect architecture of the library awakens a feeling of desperation and/or confusion among its inhabitants. In spite of these texts' logical and meticulously devised structure, chaos and disorientation abound in both works, as do the references to chaos and bifurcation theory that are artistically woven in the themes and narratives of these two unique narratives.

## Libraries as Sources of Inspiration

Libraries are commonplace in Borges's literary universe. Having spent a great deal of time at his family's library in Buenos Aires, Borges developed a natural fascination with them as essential tools in the eternal quest for knowledge and inspiration. From 1937 to 1946, he worked as first assistant at the Miguel Cané branch of the Municipal Library in Buenos Aires, where he helped catalog the library's holdings. During these years, he led essentially two parallel lives. On the one hand, he was thriving as a short fiction writer and producing some of his most celebrated pieces, including "Pierre Menard, Author of *Don Quixote*" (1939), "Tlön, Uqbar, Orbis Tertius" (1940), "The Circular Ruins" (1940), "The Babylon Lottery" (1941), "The Garden of Forking Paths" (1941), and "The Library of Babel" (1941). On the other hand, he was leading a life of "solid unhappiness" marked by the

ignorance of his co-workers and the patronizing attitude of the municipal government, which "underlined (his) menial and dismal existence" (Borges, *The Aleph and Other Stories* 241–242).[1] Adrian Lennon writes that in 1946, Juan Domingo Perón was elected president; subsequently, owing to his political inclinations, "Borges was 'promoted' to inspector of chickens and rabbits in a public market" (77).[2] In 1955, after Perón had been overthrown by a military coup and sent into exile, the military government appointed Borges Director of the National Library, a position he held until 1973,when Perón returned to Argentina after his long exile in Spain. By this time, "Borges enjoyed a comfortable income from the sale of his books and was able to live exactly as he pleased. In his case, this meant the ability to travel the world in spite of his blindness" (97).

There is no doubt that for many years libraries were Borges's real universe, an idea he would metaphorically convey in "The Library of Babel," which begins with a thorough description of the universe. Borges's fictional library is an orderly and structured space where men search for the book or books containing all the answers to their concerns: "There was no personal or universal problem whose eloquent solution did not exist—in some hexagon" ("The Library of Babel" 83). Like readers of hyperfiction who struggle with disorientation as they read the text, the subjects in this library face a constant struggle with their environment, an environment that constrains and liberates them at the same time. The men in the library of Babel think that the Library contains "the clarifications to all the mysteries of humanity" ("The Library of Babel" 84), but they are frustrated by the fact that some of the books cannot be found. These library dwellers resemble the "Reagan Library" readers who face excitement or disappointment while negotiating the narrative to arrive at the gist of the story.

"Reagan Library," which award-winning hyperfiction author Stuart Moulthrop describes as a "short-form cybertext fiction," challenges readers to see literature from a different perspective (personal interview). In his cybertext, Moulthrop takes up many of the issues elaborated by Borges in "The Library of Babel." Borgesian themes and strategies, such as the use of metaphors and the creation of labyrinthine ludic narratives, resonate throughout "Reagan Library." As Espen Aarseth observes, "hypertexts, adventure games and so forth are not texts the way the average literary work is a text" (2–3). For Aarseth, "A cybertext is a machine for the production of variety of expression" (3). Such a text engages the reader in its interpretation and "mechanical organization" (1). This type of cybertextual reading turns the text into an "ergodic text," a phrase that Aarseth defines as "one in which at least one of the four user functions, in addition to the obligatory interpreta-

tive function, is present" (65).[3] The reader of an ergodic text engages in a process of exploring, recreating, understanding, making sense of, and/or coming to terms with a text. The reader recreates the text as she moves along the different paths available to her. This process of reading an ergodic text involves taking into consideration not only the text but also the medium in which it is created and the possibilities for interpretation that it offers. The reader should become aware of the different paths available to her in the labyrinthine almost chaotic display of an ergodic text such as "Reagan Library," which allows for a variety of interpretations. Therefore, like "The Library of Babel," which to a certain extent can be understood as an ergodic cybertext because the reader must assemble all the threads of the text to understand Borges's idea of the library as the universe, "Reagan Library" goes far beyond a plot, presenting a new mode of literature that resembles strategy games, because the reader can reorganize the sequences according to what she has experienced previously. This cybertext presents a plot and also invites the reader/player to view the work as an artifact.[4] As readers traverse the story, they must make sense out of what seems disruptive or chaotic. Behind the noise—a term usually associated with chaos theory—lie a story and meaning. As Adrian Miles puts it, "'Reagan Library' probes the relation of reading and game playing, and explores the boundary between image and text based diegetic worlds, demonstrating that writing's electronic future is less about textual pyrotechnics than a refiguring of words into other narrative spaces" (par. 6).

In "Reagan Library," readers are constantly challenged to make connections even beyond the plot in order to understand the complexity of the work. Those who engage in this ergodic type of reading are in a constant state of alert since the story contains many clues that must be deciphered, as in a virtual game, in order to come to terms with the cybertext. Sense and order result not only from the presence of numerous clues, but also from their absence.

## Loops, Infinity, Geometric Shapes, and Meaning

From the outset, "The Library of Babel" and "Reagan Library" present their metaphors. Borges begins "The Library of Babel" by stating that "The universe (which others call the Library) is composed of an indefinite, perhaps infinite, number of hexagonal galleries" ("The Library of Babel" 79). This remark, as Beatriz Sarlo argues, could be understood as a subliminal reference to Pascal's conception of the world as an infinite sphere (71). Just as Borges lets the reader ponder the implications of this phrase, Moulthrop introduces his work with similar comments on the labyrinthine

structure of his fiction: "The world is what you see and where that takes you. And where would that be? You'll find out" ("Introduction," "Reagan Library"). Throughout Moulthrop's fiction, one encounters abundant references to geometric shapes whose function is not merely aesthetic. Whereas Borges appeals to the image of the hexagon to express the idea of infinity, Moulthrop uses the recurrent visual images of a sphere and a looping effect to create the virtual environments where the different plots develop. Moulthrop refers to the Borgesian view of the universe through one of his characters: "This world has a basic circularity" ("Blue Zone, Pavilion").[5]

Many of the geometric images in "Reagan Library" have embedded links that allow the reader to explore a narrative from the point of view of the main character in one of the several environments. From this perspective, readers of "Reagan Library" resemble the library dwellers in Borges's library: they gain a different perspective on the space according to their position. In effect, "Reagan Library" challenges readers to explore and gain a new understanding of the reading/writing process by utilizing this cybertext as a 'space probe.'

Each screen is composed of text and a visual block in QuickTimeVR, which loops as the reader directs. It is possible to traverse the narratives via the visual area or the text. Clicking on any of the recurrent geometric icons (sphere, cone, or obelisk) in the QuickTimeVR section or on the underlined words in the text takes the reader to a different level and/or zone of the work. Each screen has also four different states marked by a square in the lower right-hand corner. Every time the reader returns to the same screen, the text becomes more meaningful and cohesive, reaching its final form during the fourth visit.

In addition to these four states, the work has four zones designated by the colors dark grey, black, blue, and red, each of which presents a unique narrative thread with a specific perspective on the world. The dark grey zone features a deceased stand-up comedian and his psychotherapy sessions. According to Katherine Hayles, "His therapist, Dr. Ramchandra, has hooked him up to a virtual reality apparatus, presumably as therapy for his damaged sensorium. From his comments we can infer that Dr. Ramchandra is asking him to interpret the objects in the QuickTime movie, suggesting that his therapy is a weird science combination of visualization technology and a Rorschach test" ("Bodies of Texts" 271). Whereas the main character and the reader share the same visual images, each of them needs to resolve a different conflict: the comedian wants to come to terms with the traumatic experience that led to his death, and the reader strives to use the images to add

meaning to her reading experience. The black state is inhabited by a prisoner who has lost his memory and who, like the dwellers of Borges's library and the readers of "Reagan Library," tries to decode meaning and come to terms with the stimuli presented to him. A female film director named Emily St. Cloud is the main protagonist in the blue zone. Although she is dead, she constantly refers to memories from the time when she was alive. The phrase "This is the world I made, a garden of remembering" summarizes Emily's concern with memory ("Blue Zone, Pavilion"). Her voice echoes the ideas portrayed in Borges's "The Garden of Forking Paths," where the author points at the notion that past, present, and future exist simultaneously. As Hayles explains, "we know that she (Emily) is obsessed with connecting the past to the future because she takes the trouble to bury a time capsule (in the form of her car) filled with a heterogeneous collection ranging from a pistol to a box of Kleenex to stolen plastic food" ("Bodies of Texts" 273). The red zone is perhaps the most coherent. Loaded with information referring to content as well as to the technicalities of "Reagan Library," it contributes to the decoding process that the reader/player must perform. Most phrases in this zone are clues to Moulthrop's cybertext puzzle. Whereas some of them hint at the stories in the different zones, others inform the reader about hypertext criticism and literary theory. For example, the quotation "More grass than a tree," which is taken from Deleuze and Guattari's *A Thousand Plateaus,* refers to the associative power of the brain, which functions more like a rhizomatic network than an arboreal structure.[6] From a rhizomatic perspective, the reader of "Reagan Library" can enter the text from a variety of points, establish multiple connections, and chart a textual territory in a narrative that does not abide the rules of a fixed printed text or any kind of hierarchical organization. Hence, "Reagan Library" challenges the reader to derive meaning from a narrative where texts embedded with words and virtual-reality panoramas mutate, challenging the fixity of print and calling for a new interpretation of reading.

The red zone, like the Crimson Hexagon in Borges's library, leads to an understanding of the story as well as to what lies beyond it. Within this context, content and structure inform the stories and the metaphor of "Reagan Library," and the reader is reminded to establish all sorts of connections among the threads as the following quotation illustrates: "Links may cross state lines" ("Red Zone, Pavilion"). Both Borges and Moulthrop treat confusion and chaos as operative principles that generate new ideas. Nevertheless, the library dwellers, like the cybertext readers, feel a sense of entrapment as they struggle to come to terms with their chaotic environment. This perception is illustrated in one of the narrative threads by a character

who searches for knowledge: "The universe would add up nicely if only we could find the other set of books" ("Black Zone, Geode"). Borges's characters, by contrast, are trapped by their own ignorance or limitations as human beings fighting to achieve what only God can accomplish: some are guided by the superstition that one of the library hexagons contains a cipher book which can unlock the mysteries of all the other books; others believe that "on some shelf of the universe there lies a total book" ("The Library of Babel" 85).

### Order Out of Chaos: The Search for Equilibrium and Meaning

The two stories in question metaphorically convey aspects of chaos theory and bifurcation theory. According to Eric W. Weisstein, "In a dynamical system, a bifurcation is a period doubling, quadrupling, etc., that accompanies the onset of chaos" (par. 1). In the narratives I have analyzed, bifurcations mark the onset of new paths and allow us to trace trajectories rooted in organized structures. Once again, as in *Victory Garden* and "The Garden of Forking Paths," Hayles's remarks that "[a]t the center of chaos theory is the discovery that hidden within the unpredictability of chaotic systems are deep structures of order" (*Chaos and Order* 1) echo in "Reagan Library" and "The Library of Babel." "Chaos," in this usage, denotes not true randomness, but the disorder characteristic of these systems" (*Chaos and Order* 1). This concept is intimately connected to Prigogine's claim, as presented in the previous chapter that "all systems contain subsystems, which are continually "fluctuating," and eventually leading to some form of equilibrium (Prigogine xv). If one is to restore order out of the apparent chaos in Borges's and Moulthrop's works, one should interpret them within the framework of complex systems in which all the elements enter into a mutual relationship with their environment. As I have argued, "Reagan Library" provides a new approach to understanding "The Library of Babel" by recasting many of the issues in Borges's work in the context of cyberfiction and science.

### Chaotic Libraries

Moulthrop's and Borges's libraries are carefully designed spaces where chaos and confusion abound. In the words of John Casti, "Chaotic systems correspond to those librarians of Babel who read every word and character in the books under their care. In contrast, nonchaotic systems are like readers who merely look at the titles and skim the contents" (*Complexification* 289). Nevertheless, I contend that this complexity refers to the library dwellers and to the way in which Borges presents the metaphor of the universe as a library. As Beatriz Sarlo writes, the story seems straightforward in a Kafkian

way, whereby the simplicity of the plot is responsible for the aesthetic impact it produces (*Borges: A Writer on the Edge,* 70). "The Library of Babel" resembles a tapestry whose beauty derives not only from its linguistic component, but also from the artifact it represents. It is a metaphorical artifact that stands for a metaphysical concern: the reader is expected to disentangle those threads to recreate the metaphor behind it. Therefore, I suggest that there are two complex systems at play in "The Library of Babel." On the one hand, the library dwellers interact with an almost infinite number of texts, many of which are impossible for them to comprehend. Even though the library is perfectly ordered, it contains books whose chaotic arrangement of linguistic codes is indecipherable. At one point, for instance, the narrator states: "I can not combine certain letters as, dhcmrlchtdj, which the divine Library has not already foreseen in combination, and which in one of its secret languages does not encompass some terrible meaning" ("The Library of Babel" 86). On the other hand, "The Library of Babel" is an artifact, a body of text that challenges its readers to place the story within a Borgesian framework where one must differentiate between reliable information and noise to discover its metaphorical and metaphysical references.

As readers of "The Library of Babel," we also try to unlock the mysteries involved in the unintelligible system confronted by the library dwellers. As Alexander Coleman puts it, "We must trust the author when he assures us that the apparent nonsense hides a crystal-clear idea" ("Chaos and Play in Borges" 31). But how can anyone trust Borges, whose narratives are well known for juxtaposing fiction and reality? What is at stake here is the reader's ability to come to terms with Borges's opening statement. Like the library dwellers, the reader experiences a reading process similar to the one undertaken by cybertext readers who engage in what Aarseth describes as a "non-trivial effort" to traverse the text.

As Braxton A. Soderman explains:

> Thus the nontrivial for Aarseth indicates that the user's effort to traverse the medium of the text (coupled with various ways that the medium exhibits its structure to the user) is significant in the overall structure and interpretation of the literary object....How the reader "completes a text" and how the text "manipulates" this effort becomes significant; they are nontrivial and cannot be discarded or overlooked in a discussion of the text's structure or meaning. (par. 28)

This type of reading demands a thoughtful analysis not only of the content but also of the process the reader engages in. Whereas cybertext readers navigate the text by selecting different links and establishing connections that take into consideration the structure of the work, library dwellers and readers of "The Library of Babel" engage in a process of decoding that takes

into account language and the spatial structure they perceive.

Obviously, "The Library of Babel" and "Reagan Library" convey their messages with different codes and media. Whereas Borges's library portrays a fixed labyrinthine structure with hexagons that create an idea of infinity, "Reagan Library" has a meandering structure that makes tangible the underlying ideas of bifurcation theory and chaos theory. "Reagan Library" allows the emergence of multiple plots, as well as the unique experience of creating meaning out of what may look chaotic. Phrases like "Some of the language is randomly generated," "Not that any of this makes sense," or "Do you have a problem with noise?" set the tone for the readers/players, who are virtually left to their own devices as they traverse this Borgesian world. Within this framework, each transition from one screen to the next leads to a new discovery and adds more meaning to the reader's interpretation of the narrative. Fragmentation and assemblage are constant processes throughout the text. In the words of Hayles, "In reassembling the (textual) bodies, the user can never be sure if the emerging coherence is an artifact of her imagination or a pattern intrinsic to the work" ("Bodies of Texts" 260). This is especially relevant in Borges's and Moulthrop's works, where the perfectly devised chaotic worlds challenge the reader to shed some meaningful light on the texts.

### Compelling Splitting Moments: Implications for the Reader

The stories of Borges and Moulthrop have features of bifurcation theory, in so far as they portray multiple perspectives and multiple levels of time. According to Weissert, "[an] essential characteristic of bifurcations in nonlinear physical systems is that, at the splitting, chance determines which path the system will take" (234). In Borges's story, for example, the reader is compelled to deal with different levels such as plot and metaphor. Therefore, the 'splitting moment' is determined by the reader's choice to deal with the story as plot or as metaphor. Similarly, in Moulthrop's work, the reader encounters several story lines as she attempts to deduce some meaning from the structure of the work. Whereas Borges uses language exclusively to stimulate the reader's imagination, Moulthrop adds another layer of complexity to his work by incorporating digital technology that forces the reader to assemble the different levels of the texts to arrive at the metaphorical implication of this cybertext. In both works, what is said and what is omitted play a relevant role. In order to comprehend the multiple levels of these stories, it is necessary to think of the language that is available to us and of the language that is latent and ready to emerge from one of the bifurcations.

"Reagan Library" is partly algorithmically generated, and these algorithms produce bifurcating points, adding either comprehension or noise to the cybertext. As Moulthrop asserts, "Much of what you read on your first visit may seem like nonsense: in fact it's generated by a set of simple random-assembly programs. The text should become more coherent (if not more sensible) on repeated visits" ("Reagan Library," Introduction). At different points in the narrative, the reader is almost magically transported from one virtual environment/plot to another. On some occasions, she faces unexpected bifurcations, which can take the shape of a leap out of context or the movement from a coherent state to a less coherent one. These leaps force the reader to reassess her understanding of the story/ies, as well as the meaning behind the noise and chaos. The stories that stem from these disjunctions are interwoven in such a way that the transitions from one to another leave the reader in awe of the plot twists. This structure and its language seduce the reader into creating multiple worlds, points of view, and a new perspective of literature. This new approach, as previously observed, immerses the reader in a non-trivial act of comprehension that takes into account the role played by different media and technological applications in shaping new interpretations of a literary text.

## Metaphorical Libraries

What do "The Library of Babel" and "Reagan Library" ultimately stand for? To a certain extent, both texts address a common concern: How can our almost endlessly evolving and chaotic universe be represented and/or understood? Ironically, neither library provides a definite answer. Borges's library dwellers look desperately for the book with all the answers, while the "Reagan Library" reader wanders back and forth through the text trying to decipher its clues. Neither work offers a solution beyond its opening statements, although both emphasize the demanding cognitive process involved in reading. "The Library of Babel" and "Reagan Library" demonstrate that language, science, and technology can only allow us to imagine—and never fully understand—the complexities of the universe. Whereas Borges achieves this goal by presenting a fictional narrative that illustrates the chaotic nature of the universe, Moulthrop, by contrast, takes advantage of language, including programming language and the technological developments of his time, to create a deep structured, noisy, and chaotic world that lets the reader grapple with complexities of interpretation.

**Rapprochement:**
**Print Text and Twenty-First Century Digital Literature**

"The Library of Babel" and "Reagan Library" constitute a type of rapprochement between literature and science, time and space. This convergence of print and digital literature allows readers to explore the intimate and almost unavoidable connection between Borges's pioneering work and its twenty-first century counterparts. With its near materialization of Borges's ideas, and with its mathematical and metaphysical concerns, Moulthrop's cybertext helps create a new area of study whereby science and literature endlessly relate to each other as part of a complex environment. By bringing to the fore issues related to science, language, critical theory, hypertext theory, media, and Borges's metaphysical ideas, "Reagan Library" reinterprets "The Library of Babel" and underscores Borges's pioneering conception of the universe as expressed through literature.

Whereas Borges succeeded in illustrating metaphysical, scientific, and technological ideas through his short fictional narrative, Moulthrop takes this concept a step further, enhancing the idea of a chaotic universe and a bifurcating system by means of his programmed cybertext. In the process, he challenges its interpretative possibilities and opens up the possibility to see Borges's work from a new perspective. Hence, reading "The Library of Babel" while taking into consideration "Reagan Library" underscores the integral connection between the text itself, "Reagan Library," and science, giving modern readers a new tool for understanding Borges's works.

# Notes

[1] It was during this time that the municipal government of Buenos Aires would reward its workers for good work with two kilos of *mate*.

[2] The fact that he was 'promoted' to this new position made Borges feel as if he had in fact been demoted.

[3] The other three functions Aarseth refers to are textonic, configurative, and explorative. For further explanation, see Aarseth 65.

[4] For a discussion on the literary text as an artifact, see Hayles, *My Mother Was a Computer Machine: Digital Subjects and Literary Texts* 104.

[5] I cite "Reagan Library" by the color of the zone and the name of the lexia.

[6] Deleuze and Guattari distinguish "rhizomatic thought" from "arboreal thought." Whereas "rhizomatic thought" and networks extend horizontally and relate to non-linear linkages and non-hierarchical organization, "arboreal thought" alludes to a vertical and hierarchical organization. See *A Thousand Plateaus* 7.

# Chapter 8

# North Meets South: Jorge Luis Borges's "The Interloper" and Natalie Bookchin's Media Experiment *The Intruder*

For new media to exist, a great deal of experimentation and programming had to be undertaken, much of it at a very low level and requiring great technical skill and effort. Borges was no hacker, nor did he specify the hypertext novel in perfect detail. But computers do not function as they do today only because of the playful labor of hackers or because of planned-out projects to program, develop and reconfigure systems. Our use of computers is also based on the visions of those who, like Borges—pronouncing this story from the growing dark of his blindness—saw those courses that future artists, scientists and hackers might take.

Nick Monfort, *The New Media Reader*

## A Chronology of Borgesian Themes in Digital Works

In the previous chapters, I have examined the intimate relationship among Borges's "The Library of Babel" and "The Garden of Forking Paths," Moulthrop's *Victory Garden* and "Reagan Library," and science and technology. Previous chapters have also illustrated how Moulthrop's Borgesian works have evolved from black and white hypertexts into complex literary works created in multimedia environments where technology enhances the ludic and creative role of the reader—which is also a landmark of Borges's approach to literature.

Moulthrop's pioneering work marked just the beginning of a steady production of electronic literature, media installations, and video games that refer directly to Borges's oeuvre. Throughout the last decade of the twentieth century and beginning of the new millennia, hyperfiction writers and critics, Web artists, and video game programmers, many of them from the northern hemisphere, have incorporated Borgesian themes in their work, creating a body of work that has provided audiences with alternative ways to refer to and therefore interpret Borges's works.

Although this chronology does not pretend to be an exhaustive list of the contemporary digital work that is intimately connected to Borges's ideas, it does provide the reader with a varied sample of digital work embodying Borges's metaphysical, theoretical, and social perspectives, and/or remediating some of Borges's most acclaimed short stories.

Among the commercially produced video games, *Riven* (1997) almost magically reproduces Borges's world as portrayed in his 1940 short story "Tlön, Uqbar, Orbis Tertius."[1] As in Moulthop's works, *Riven's* Borgesian

fantasy worlds engage its player in a puzzle to a solution where gaming, art, and language are digitally intertwined.

Within the realm of Web-based artifacts, "Babel" (2001), "Book of Books I" (2003), and "Book of Books II" (2003) by Simon Biggs illustrate Borges's influence in our digitally mediated art and society. Biggs's art brings into play Borgesian themes, such as the idea of the infinite book, the book that contains all books, and the beauty of chaos, as presented in Borges's library and Biggs's Babel.[2]

In the context of literary criticism and remediation, Marjorie C. Luesebrink's multimedia presentation "The Simultaneous South: An Electronic, Multilinear Approach to Borges' 'The South (2003),'" presents a unique and provocative interpretative exploration of Borges's "print conceived short story" (Luesebrink 2003). In her essay, Luesebrink's underscores Borges's fascination with symmetry, binary settings, and multilayered plots, as well as with the innate features of contemporary technology that makes possible the representation of those concepts possible. Her essay, which was originally presented at the 2003 Modern Language Association annual convention, undoubtedly sets the tone for a new approach to the study of Borges's works within the framework of multimedia as a "vehicle for studying a print short story' (Luesebrink 2003). Luesebrink makes her audience aware of the nature and future possibilities of her essay by acknowledging that even though it was created to be read by her to an audience, "eventually an interested reader might be able to unpack the elements of this 'essay' at her own computer screen" (Luesebrink 2003).

Luesebrink's brief but powerful multimedia essay conveys the two threads of Borges's short story. Each thread mirrors the other as if they were two parallel symmetric accounts of Juan Dahlmann's life. In "The South," the reader learns about Dahlmann's Germanic ancestors, his nationalistic ideals, his love for solitude, his lack of interest in fictitious worlds, and his relative fascination with real life. The reader is also informed of Dahlmann's dreamlike experience in a sanitarium resulting from an accidental self-inflicted wound he accidentally inflicted upon himself. Dahlmann's tragic incident magically blurs the clear-cut distinction between reality and dream in the two stories. As the narrator in "The South" openly admits, "it was as if he [Dahlmann] was two men at a time: the man who traveled through an autumn day and across the geography of the fatherland, and the other one, locked up in a sanitarium and subject to methodical servitude" ("The South" 170).

Not only does Luesebrink wittingly present and intertwine the two layers elaborated by Borges in his story, but she also presents the text in such a way

that opens further interpretative layers based on the readers' own understanding of the text. With her use of images, especially the recurrent image of a window and a pink building that, in her own words, "is so much like the gaunt, old manor of the Pampas," Luesebrink evokes Borges's technique of "anchor[ing] us in the places of his experience" ("The Simultaneous South"). In so doing, Luesebrink triggers another bifurcating path that subliminally takes the reader to Borges's autobiographical references in this story—in particular, such as the well—known incident on Christmas Eve 1938 when Borges hit his head on with the sharp edge of a window, which led him to be hospitalized due to septicemia. Both Borges's own story and Luesebrink's remediation and hypermediated criticism of the text create anew this crucial episode, which Borges feared would result in a loss of creativity. Fortunately, Borges's anxieties were unfounded. After this event, he produced some of his most acclaimed short stories, including "Pierre Menard, Author of *Don Quixote*" and "Tlön, Uqbar, Orbis Tertius," stories that clearly spell out Borges's critical stance regarding the work of art, the creative process behind it, and the metaphysical milieu it represents.

Most Borgesian artifacts, except those whose origins are linked to "The Interloper" and "The South," share two unique features: first, they are inspired by *Ficciones,* Borges's acclaimed collection of short stories that has fascinated mathematicians, physicists, the literati, and the digerati alike for their embedded mathematical references, metaphysical themes, and futuristic views[3]; and second, they were produced in English in the northern hemisphere, thus setting up scenarios where North meets South in new digital environments. To illustrate how the northern hemisphere has embraced Borges's work in a new light that underscores Borges's fascination with the ludic aspect of a narrative, I refer to the points of convergence and divergence between Borges's "The Interloper" and Natalie Bookchin's (1999) experimental multimedia narrative, *The Intruder,*[4] which takes Borges's straightforward story "The Interloper" (which is not part of *Ficciones)* to a new realm via the interplay among electronic narrative, audio, and a series of arcade games.

Taking into consideration the medium in which each work was created, I sketch out below the role of images, language, and imagination in the reading of "The Interloper" and its multimedia counterpart. Moreover, this reading of "The Interloper" via *The Intruder,* which contains within it ten eighties-style arcade video games, underscores the role of the video games in connection to Borges's work, as well as the sharp feminist image they provide of the roles of men and women in the patriarchal society described by Borges in "The Interloper."

## North Meets South

Bookchin's *The Intruder* (1999) marks the beginning of a new period in the history of game-inspired art work developed by women. According to Tiffany Holmes, "[i]n the late 1990's women publicly laid claim to the crowded territory of the male-dominated gaming world"; however, "[t]o develop a feminist politics and activist trajectory in cyberspace girls need to develop their own games" ("Art Games and Breakout: New Media Meets the American Arcade"). This is exactly what Bookchin accomplishes: she opens up a new space for women and the role of video games in the evolving digital realm.

Bookchin envisioned Borges's "The Interloper" as the perfect story for developing a theme based on her own interest in the role of women in a patriarchal society. She relied on net art—a free, Internet-based medium that could potentially provide her with a nearly perfect environment to express her opinions. What Bookchin had in mind was not only to examine the role of women in a patriarchal/*machista* society and the role of women within the gaming community, but also to underscore the misogynistic and brutal nature in Borges's story. In a personal telephone interview with the author, Bookchin reminded the author that "Borges did not push the topic of brutality as much." Bookchin found Borges's tone somewhat "disaffected." She intended to bring the issue of brutally to the foreground to "make that into a reality," something that "is not abstracted like in a conventional game" (personal interview). Whereas Borges's narration provided Bookchin with the perfect material to instantiate her ideas, the arcade games she selected and those she programmed to create *The Intruder* contributed to accomplishing her objectives. By remediating Borges's highly nationalistic and regionalistic text, Bookchin reaches towards the South.[5] She turns "The Interloper" into a more universal story illustrating the brutality and displacement of women that emerges from highly male-dominated environments and the emerging role of women in a game-oriented society.

## "The Interloper": Language, Images, and the Imagination

"The Interloper" (1966) is characterized by Borges's succinct narrative as well as by his depiction of women within the Argentine society at the turn of the twentieth century. According to Borges, "the hint for this story" came out of a chance conversation with his friend don Nicolás Paredes sometime back in the late twenties. During this conversation, they commented on "the decadence of tango lyrics, which even then went in for 'loud self-pity' among sentimental *compadritos* betrayed by their wenches" (Borges, *The Aleph and Other Stories* 162). Thus, "The Interloper" unveils a feeling of

revenge towards women as well as the insurmountable feeling of brotherhood between the two male characters.

Borges, who was going almost completely blind at the time, dictated this story to his mother. In spite of disliking it from the outset, she provided him with the necessary words to conclude it: "Now they were linked by yet another bond: the woman grievously sacrificed, and the obligation to forget her" ("The Interloper" 351). Borges considered "The Interloper" to be the "best story" he had ever written (*The Aleph and Other Stories* 278). This short story, departing in style from Borges's universal metaphysical narratives exemplified by *Ficciones,* allows the reader to take a glimpse of a typical town in the outskirts of Buenos Aires towards the late nineteenth and early twentieth centuries. Through a meticulously crafted narrative, Borges immerses the reader in an Argentinean town and the lives of two brothers—Cristián and Eduardo—who engage in a love triangle with Juliana Burgos. Throughout the story, these two brothers put their instincts to the test as they try to preserve their own identity and brotherhood.

The female character in "The Interloper" plays an important role because her presence or absence causes a radical change in the story.[6] She is the main catalytic figure around which the plot develops; the narrative projects a unique interpretation of manhood, womanhood, and brotherhood, or of the relationship among these terms. In Borges's story, Juliana *is* the interloper, and as such her voice is never heard. Her silence bespeaks her presence as well as her submission, her destiny, and her fatal ending.

Borges relies on detailed descriptions to depict Cristián's, Eduardo's, and Juliana's personalities and their physical surroundings. In reference to the Nilsen's house, we are told:

> The big ramshackle house (which is no longer standing) was of unplastered brick; from the entryway one could see a first interior patio of red tiles and another, farther back, of packed earth. Few people, however, entered that entryway; the Nilsens defended their solitude. They slept on cots in dilapidated and unfurnished bedrooms; their luxuries were horses, saddles, short-bladed daggers, flashy Saturday night clothes, and the alcohol made them belligerent. ("The Interloper" 348–349)

Similarly, a brief description of Juliana introduces her with certain candor in contrast to the brutal ending that awaits her: "Juliana had almond eyes and dark skin; whenever someone looked at her she smiled. In a humble neighborhood, where work and neglect make women old before their time, she was not bad-looking" ("The Interloper" 349). By presenting this contrast, Borges subliminally underscores the Nilsens's strong brotherly bond and heartlessness towards others.

Borges's sagacious use of language creates a story that is surrounded by a cloud of mystery. The reader's challenge is to figure out the truthfulness of the story: "They say (though it seems unlikely) that Eduardo, the younger of the Nelson brothers, told the story in eighteen-ninety-something at the wake for Cristián, the elder, who had died of natural causes in the district of Morón" ("The Interloper" 348). Borges also emphasizes idea of vagueness in "The Interloper" by situating it in "an almost nameless town to the south of Buenos Aires so that nobody could dispute the details" (Borges, *The Aleph and Other Stories* 278).

It is also via language, or the absence of language, that Borges unmasks the personalities of his characters. Even though we can almost picture Cristián's and Eduardo's actions, the reader can only hear Cristián's voice. Cristián is the eldest brother, and his four interventions in the narrative are direct commands to Eduardo. These orders denote an air of superiority on Cristián's part, while debasing the role of Juliana, the female character of this story, as in the following example where Cristián tells Eduardo: "I'm going off to that bust over at Farias' place. There's Juliana—if you want her, use her" ("The Interloper" 350). This also takes us back to the idea of silence with respect to Juliana. We never hear her voice, and she almost instinctively accepts the role she has been assigned by society. The first time Juliana's name is mentioned in the text, Borges tells us: "There was a good deal of talk, therefore, when Cristián carried Juliana Burgos home The truth was, in doing so he had gained a servant, but it is also true that he lavished ghastly trinkets upon her and showed her off at parties" ("The Interloper" 349).

The Nilsens have a tacit brotherly agreement that has been sealed by silence. Once again, as in Juliana's case, silence is relevant. In the beginning, Juliana is Cristian's woman and, for that reason, Eduardo stays away from her. As the days go by, Eduardo falls in love with Juliana and, at his brother's friendly command, Juliana becomes Eduardo's woman as well. Even though the arrangement works for a few weeks, there comes a point when the brotherly relationship starts to deteriorate. Eduardo and Cristián do not mention Juliana's name. Instead, they argue about trivial matters, though both know that the Other, the interloper, is the real cause of their arguments: "In those hard-bitten outskirts of the city, a man didn't say, nor was it said about him, that a woman mattered to him ( beyond desire and ownership), but the two brothers were in fact in love. They felt humiliated by that, somehow" ("The Interloper" 350).

Silence brings the Nilsens together as well as distancing them. At a certain point in the story, the reader is informed that the brothers look for any excuse to have a quarrel. They use trivial conversation as excuses for

arguments. It is clear that their silence and their repressed voices cause them to draw apart. Within this framework, and as in many instances where authority is compromised, the subaltern is likely to remain silent to maintain the stability of the system. At this point in Borges's story, Eduardo represents the subaltern, whose voice remains unheard in order to preserve brotherhood.

Two facts lead to the men's decision to get rid of the interloper. One day in the street, Eduardo is congratulated by a man for the beauty who accompanies him. At that moment, he realizes that he that he cannot allow someone to make fun of Cristián. Moreover, Juliana has not been able to hide her preference for the younger brother. The Nilsens sell Juliana to a whorehouse and split the money. Peace is reestablished at the Nilsens's house. The brothers go back to their "old life of men among men," except for their frequent and secretive visits to the brothel ("The Interloper" 351). Neither of them can be away from Juliana, and their trust in each other is almost shattered when Cristián finds Eduardo—who is supposed to be on a business trip in the city—at the whorehouse waiting his turn. Realizing that they have betrayed each other and that their feelings for each other as brothers are still strong, they take Juliana back to their house to settle the matter. They do not blame each other because "they chose to take their exasperations on others: a stanger—the dogs—Juliana, who had introduced the seed of discord" ("The Interloper" 351).

On a quiet Sunday evening when Cristián and Eduardo arrived at a lonely area with tall reeds, Cristián tells his brother: "Let's go to work, brother. The buzzards'll come in to clean up after us. I killed 'er today. We'll leave 'er here, her and her fancy clothes. She won't cause any more hurt" ("The Interloper" 351). Brotherhood survives in spite of the interloper, an intruder that they both brought to their lives. Their loyalty to each other remains stronger than love and the hard times they had faced together.

I concur with Rebecca Biron that "The Interloper" informs the reader "that the successful construction of male-center worlds depends on vigilance against female intrusion" (32). Biron claims that "'La intrusa' ['The Interloper'] illustrates the tragic extremes to which such a principle might be taken by two ignorant, particularly vulnerable men whom neither the narrator nor the readers accept as representative of men in general" (32). However, Borges's approach to the subject remains somewhat detached, as if leaving open a space for exploration via the digital realm.

### *The Intruder:* North Meets South—"The Interloper" Revisited

Bookchin's rendering of Jorge Luis Borges's short story is presented in a multimedia environment where visual, kinetic, and auditory stimuli reaffirm and highlight the treatment of women as developed in Borges's "The Interloper." Bookchin claims that the challenge with new technologies is to turn them into "socially charged activities": "*The Intruder*...looked like a game but in fact was a critical commentary on computer games and patriarchy" (Boockchin, interview with Beryl Graham). Her experimental work opens up a space for questioning the role of women in the gaming community at the end of the twentieth century. In Bookchin's words, "'*The Intruder*' isn't really a game, it just uses the game form as an interface and metaphor, and the user moves through these interfaces, actively performing the text. The game form is a great vehicle through which to speak to aspects of mainstream computer cultures—their military and political and economic uses" (Bookchin, interview with Mia Makela).

Similarly, Bookchin's *The Intruder* reveals a new dimension of Borges's cruel and candid story. The interplay of visual, audioauditory, and kinetic media allows for the emergence of new interpretations. In reference to the role of the reader in *The Intruder,* Bookchin states: "You have to play it a number of times because you are playing it and you are also receiving bits of narrative" (Bookchin, "I Love You So Much It Hurts: Playing Games"). Hence, the reader functions as an active player and as a decoder of Bookchin's agenda. As a player, the reader *is* the intruder who also becomes the Nilsens' accomplice in Juliana's fate. As decoder, the reader comes across topics such as the role of women in the gaming community and the power of media to relay information to a broad audience.

*The Intruder* can be read either in English or in French.[7] From the very beginning, the reader/player must actively engage in the unraveling of the story; otherwise, the story does not move forward. Borges's text scrolls on the screen as the reader plays ten eighties-style arcade video games. In several of the games, the reader/player needs to push one object—which could very well represent Juliana—back and forth, as in the pong, for the text to move forward. The games are titled as follows: *Pong; Catch Dropping Words; Shoot Alien; Quick Draw; Jump; Hit Girl; First Road Trip; Score Goal; Others;* and *Second Trip.* In most cases, the titles make reference to the content in that section of the narrative that they represent as a metatext.

*Pong* presents the epigraph of "The Interloper" as well as the introduction to *The Intruder.* As the reader engages in the *Pong* game, the text unravels from left to right and a voice reads it. The reader's flat tone of voice echoes Borges's disaffected tone in his story.[8]

In *Catch Dropping Words*, the reader catches words into a *mate*, a hollow gourd used for drinking an infusion typical from Argentina, Paraguay, and Uruguay. The audio is activated each time the reader catches an object into *el mate;* failure to catch an item leaves the reader just with the written text. *Shoot Aliens* adds violence to the scene, because in order to continue, the reader must engage in a non-stop shooting at UFOs. This game foreshadows the brutality that is to unravel in the Nilsens's lives. It also depicts the Nilsens and their isolated house in the pampas under what seems to be an endless starry sky. By simultaneously representing violence and peace, Bookchin underscores the Nilsens's personalities as described in "The Interloper." On the one hand, the Nilsens "defended their solitude," whereas on the other "it is not impossible that one or another killing had been their work" ("The Interloper" 349). It is here where Bookchin takes some poetic license. First, she adds the sentence, "The neighborhood feared the Nilsons" (Bookchin, *The Intruder*). In so doing, she signals the heartlessness nature of the male characters. Second, and within the same sentence, she has transformed the "Nilsens" into the "Nilsons." She has transgressed barriers, making the last name more familiar to an English-speaking audience.

*Quick Draw* displays the image of a lonely rider with a woman in the pampas. The rider could very well stand for Eduardo and one of his women. At this point, the video scenes closely match the narration. As the story proceeds, two men engage in what resembles a duel while a picture of a woman acts as an omnipresent figure in the men's lives. The reader/player assumes one of the roles "turning the game into a reality" that is "not abstracted like in a conventional game" (Bookchin, personal interview).

In *Jump*, Bookchin summons the player to become the woman running away from her misfortunes. Hence, the artist offers the reader the possibility of changing perspectives as the story proceeds. Sometimes the player is the one of the men, and at other times becomes the persecuted woman.

Bookchin literally delineates Juliana's fate via a pong-like game entitled *Hit Girl.* An image of a girl bounces back and forth, simulating how the two men share Juliana. A red screen serves as a background for the game where female body parts flash intermittently. At this point in the narrative, the brothers have grown apart and have decided to take a *First Road Trip* to get rid of the woman. With reference to this fragment, which graphically shows the packing of Juliana's possessions as she departs from the Nilsens's house, Katherine Hayles states: "Another darkly funny game presents the user with two-buttock like circles with a hole between them, from which fall objects associated with the woman, which the user tries to catch moving a bucket" (Hayles 2000). Among these items is a red apple, probably an allusion to the

apple in the biblical story of Adam and Eve. The reader is left to infer that once the apple is gone, no more problems will arise between the brothers.

In the next two segments, *Score Goal* and *Others,* Bookchin artistically intertwines sound, images, and text to bridge the gap between North and South. At this stage, the artist underscores the Nilsens's machismo and their vindictiveness towards Juliana for having disrupted their brotherly bondage. *Score Goal* starts with tango music to set the tone of the brothers return to their macho routines. In Bookchin's piece, masculinity is evoked by engaging the reader in a brief football game that distances the reader from the local reference to the Argentinean pampas, where soccer is played. The reference to the football game is likely to appeal an American audience. *Others* calls for a double interpretation. It alludes to us as readers and intruders who have in our hands Juliana's destiny. Throughout this section, the reader will attempt to save Juliana from falling into a drain. However, the narration of the text only proceeds when the woman falls into the hole. At this point, it is impossible for the reader as intruder to rescue Juliana because action or the lack of thereof leads to the same event. For the story to proceed, the woman needs to fail. Similarly, the idea of "others" is in line with Borges's story, in which the Nilsens take their feelings out onto "others." In this case, it is clear that they have decided to take revenge on to Juliana for having damaged their brotherhood.

Finally, *Second Trip*—the last game—presents Juliana's unavoidable death. The sequence engages the reader/player in an aerial human hunt from a helicopter where the individual below has no possibility to survive. For the narrative, to conclude the intruder must die. Only then will the reader find closure in her experience and see the unexpected banner reading "GAME OVER."

## Interpretation

In a very Borgesian way, *The Intruder*'s reader/player recreates the text as she puts together her experience with the games and impressions from the audio, text, and images presented to her. This allows for a re-interpretation that takes into account the impressions left by the visual, auditory, and kinetic experience. According to Bookchin, *The Intruder* is "using both the feedback loop [of a game] and the hook of the narrative ("I Love You So Much It Hurts: Playing Games").

*The Intruder* adds relevant aspects to a new reading of "The Interloper." For example, the gaming nature of the piece transforms the reader into a first-person participant who in turn shifts perspectives as the story develops. At times, the reader becomes an intruder and an accomplice in this love

triangle where the woman must disappear. Thus, Bookchin is definitely invoking that feeling of "vigilance against female intrusion" as elaborated by Biron (Biron 32). The reader (either a man or a woman) must kill in order to protect the Nilsens's brotherhood. Finally, the reader joins them in a final rampant shooting to reach the ending of the story. The woman becomes an object and a subaltern who is a victim of the Nilsens's violent and brutal actions to preserve their brotherhood. Bookchin's *The Intruder* awakens new feelings and emotions which are not literally expressed in Borges's printed text but which are emphasized via the interaction between player and narrative in the new medium.

Bookchin has translated or remediated "The Interloper" into a new medium. In so doing, she has transformed it into an appropriate narrative that functions as "a metanarrative for the history of computers where there is this symbiotic relationship between man and machine that historically the woman has been left out" (Bookchin, "I Love You So Much It Hurts: Playing Games"). Similarly, she has used it "to reach audiences who are not limited to self-selected art viewers," (Bookchin, interview with Mia Makela). From my perspective, Bookchin has also successfully taken advantage of the new medium and media to elaborate on the Nilsens's brutal thirst for lust and revenge to bring back equilibrium into their own lives.

To conclude, there is no doubt that both works succeed in their portrayal of women within the aesthetics of each creator. Borges, as typical of his writing, creates a narrative world where doubt lingers in the story and the reader's imagination prevails. His native land and its people become his instrument to develop one of his favorite topics: Destiny. Bookchin, on the other hand, has taken Borges's straightforward but also mysterious "The Interloper" to a new ludic virtual realm that Sr. Borges would have appreciated and probably enjoyed, taking into consideration his passion for challenging his readers to comprehend complete universes based on his unique literary mind games. With its heavy reliance on the visual, kinetic and auditory elements of its video games, *The Intruder* depicts a sharper keen feminist image of the roles of men and women in the patriarchal society described by Borges. Thus, *The Intruder* is here for us to experience and to tell us something about human nature and the extraordinary power of the technologies of our times.[9] It is also here to remind us of the atemporal impact of Borges's works on spaces and times far beyond Borges's native twentieth-century Argentina.

# Notes

[1] For a brief introduction to the points of convergence between Borges's "Tlön, Uqbar,Orbis, Tertius" and *Riven* see http://web.archive.org/web/20011117115104/www. feedmag.com/vgs/re.html.

[2] A review of Simon Biggs's Babel by Steve Dietz can be accessed at http//: hosted.simonbiggs.easynet.co.uk/babel/intro.htm. Similarly, Biggs's statement on the Books of Books can be found at http://hosted.simonbiggs.easynet.co.uk/bookofbooks/ statement.htm.

[3] According to the *Merriam-Webster Online Dictionary,* the word *digerati* means "persons well versed in computer use and technology." For further specifications on this word go to http://www.m-w.com/dictionary/digerati.

[4] Natalie Bookchin is a world-renowned media artist and co-director of the Program in Photography and Media at the California Institute of the Arts.

[5] According to Jay Bolter and Richard Grusin in *Remediation: Understanding Media*, "The very act of remediation ensures that the older medium cannot be entirely effaced; the new medium remains dependent on the older in acknowledged and unacknowledged ways." For further explanation, see *Remediation* 47.

[6] "The Interloper" is one of the few Borges's stories where a woman plays a relevant role within the narrative. "Emma Zunz" and "El muerto" also underscore the presence of women within Borges's short stories. See Herbert J. Brant's article "The Queer Use of Communal Women in Borges' 'El muerto' and 'La intrusa.'"

[7] A beta version of *The Intruder* included the text in Spanish as well.

[8] A Spanish female provides the voice for *The Intruder's* English version.

[9] The author would like to thank the two anonymous readers who provided insightful comments to strengthen the introduction and conclusion of this essay.

# Epilogue
# Back to the Future

This Borgesian analytical adventure, which started with an exploration of the development of the intricate relationship between the humanities, hypermedia, and Borges's theoretical approaches to reading and writing, took us along bifurcating theoretical paths that enhanced our interpretation of Borges's texts from a new perspective embracing technology, science, and critical theory. Eco's theory of the open work and his classification of labyrinths, Deleuze and Guattari's rhizome theory, and Foucault's essay "Language to Infinity" underscore the role of literary theory in establishing points of convergence and divergence between Borges's printed texts and their corresponding multimedia remediations or critical interpretations.

At the core of this process of rediscovery and exploration of Borges's texts from a new perspective is the role of science, especially chaos and bifurcation theory, noise, and complex systems, as a key element in the creation of this new framework to study Borges's short stories. This approach is enhanced by assigning to technology a significant role as an element of a complex triad encompassing the text, science, and technology. Technology joins text and science as one more element in a complex system where rapid technological advances push the limits of interpretation in new and almost unimaginable ways.

As technology continues to evolve, one can foresee almost infinite bifurcations stemming from Jorge Luis Borges's oeuvre and evolving from a proliferating body of interdisciplinary scholars and artists whose work continues to be influenced by the Argentine's pioneering ideas. Thus, the realization of Borges's postprint ideas will continue to emerge as a natural continuum and evidence of his visionary theoretical approaches to the world, reading, and writing, not only today but in years to come. As Borges proclaimed "each writer creates his precursors. His work modifies our conception of the past, as it will modify the future" (*Other Inquisitions* 108). In doing so, he subtlety acknowledged the projection of his oeuvre into the twenty-first century. Borges envisioned that his short stories could be approached as pioneering twenty-first century digital works, yet the quickly evolving digital and virtual technologies of our times will almost indefinitely pave the way for novel interpretations of Borges's futuristic ideas.

# Works Cited

Aarseth, Espen. *Cybertext: Perspectives on Ergodic Literature.* Baltimore: Johns Hopkins UP, 1997.

Adams, Hazard, ed. *Critical Theory Since Plato.* New York: Harcourt Brace Jovanovich, 1971.

Barrenechea, Ana María. *Borges: The Labyrinth Maker.* Ed. and trans. Robert Lima. New York: New York UP, 1965.

Barthes, Roland. "The Death of the Author" in *Critical Theory Since Plato.* New York: Harcourt Brace Jovanovich, 1971.

Bell-Villada, Gene. *Borges and His Fiction: A Guide to His Mind and Art.* Austin: U of Texas P, 1999.

Berners-Lee. Tim. World Wide Web Seminar 1991. World Wide Web Consortium. 2 July 1999. 10 December 1999 <http://www.w3.org/ Talks/General.html>.

Biggs, Simon. Home page. *Book of Books I.* 2003. 10 August 2005 <http://hosted.simonbiggs.easynet.co.uk/bookofbooks/book1.htm>.

——. *Book of Books II.* 2003. 10 August 2005 <http://hosted.simonbiggs.easynet.co.uk/bookofbooks/book2.htm>.

——. *Babel.* 2001. 10 August 2005 <http://hosted.simonbiggs.easynet.co.uk/babel/statement.htm>.

Biron, Rebecca. *Murder and Masculinity: Violent Fictions of Twentieth-Century Latin America.* Nashville: Vanderbilt UP, 2000.

Bolter, Jay David. *Writing Space: The Computer, Hypertext and the History of Writing* Hillsdale: Lawrence Erlbaum, 1991.

Bolter, Jay David and Richard Grusin: *Remediation: Understanding New Media.* Cambridge, MA: MIT P, 2000.

Bookchin, Natalie. "I Love You So Much It Hurts: Playing Games," Lecture at UCLA EDA. February 2000. 10 August 2005 <http://dma.ucla.edu/ events/calendar.php?ID=170>.

——. *The Intruder.* 1999. 10 August 2005. <http://www.calarts.edu/ ~bookchin/intruder/>.

——. Interview with Mia Makela. "An Interview with Natalie Bookchin." *Intelligent Agent* 3 (2) (2003). 10 August 2005 <http://www.intelligentagent.com/archive/Vol3_No2_gaming_bookchin.html>

——. Interview with Beryl Graham. "New Media, 'Community Art,' and Net.art Activism." January 2001. 10 August 2005 <http://www.newmedia.sunderland.ac.uk/crumb/phase3/nmc_intvw_bookjack.html>.

——. Telephone interview. 17 April 2005.

Borges, Jorge Luis. "The Wall and the Books" in *Jorge Luis Borges: Selected Non-Fictions.* Ed. Eliot Weinberger. Trans. Esther Allen, Suzanne, Jill Levine, and Eliot Weinberg. New York: Viking, 1999.

——. "An Autobiographical Essay" in *The Aleph and Other Stories 1933–1969.* Ed. and trans. Norman Thomas di Giovanni. New York: Dutton, 1970. 203–260.

——. "The Intruder" in *The Aleph and Other Stories 1933–1969* Ed. and trans. Norman Thomas di Giovanni. New York: Dutton, 1970. 161–166.

——. *Dreamtigers.* Trans. Mildred Boyer and Harold Morland. Austin: U of Texas P, 1964.

——. *Ficciones.* Ed. Anthony Kerrigan. New York: Grove P, 1962.

——. "The Garden of Forking Paths" in *Ficciones.* Ed. Anthony Kerrigan. New York: Grove P, 1962.

—— "The Library of Babel" in *Ficciones.* Ed. Anthony Kerrigan. New York: Grove P, 1962.

——. "The South" in *Ficciones.* Ed. Anthony Kerrigan. New York: Grove P, 1962.

——. "A Note on (toward) Bernard Shaw" in *Labyrinths: Selected Stories and Other Writings*. Ed. Donald A. Yates and James E. Irby. New York: New Directions Books, 1962.

——. *Other Inquisitions 1937–1952*. Trans. Ruth L.C. Simms. Austin: U of Texas P, 1964.

——. *A Universal History of Infamy*. Trans. Norman Thomas di Giovanni. New York: Dutton, 1972. 13.

Brant, Herbert J. "The Queer Use of Communal Women in Borges' 'El muerto' and 'La intrusa.'" 10 August 2005 <http://lanic.utexas.edu/ project/lasa95/brant.html>.

Bruns, Gerald. *Heidegger's Estrangements*. New Haven: Yale UP, 1986.

Bush Vannevar. "As We May Think" *The Atlantic Monthly* July 1945. 5 December 1999 <http://www.theatlantic.com/unbound/flashbks/computer/ bushf.htm>.

Calvi, Licia. "Lector in Rebus": The Role of the Reader and the Characteristics of Hyperreading" *Proceedings of the ACM Conference on Hypertext*. Ed J. Legget, K. Tochtermann, J. Westbomke, U. Will. Darmstadt: Association for Computing Machinery, 1999. 101–117.

Calvino, Italo. "La Sfida al Laberinto." *Una Pietra Sopra*. Turin: Einaudi, 1980. 164–181.

Capobianco, Michael F. "Quantum Theory, Spacetime and Borges's Bifurcations." *Ometeca* 1.1 (1989): 27–38.

Casti, John. *Complexification: Explaining a Paradoxical World Through the Science of Surprise*. New York: Harper, 1994.

Coleman, Alexander. "Chaos and Play in Borges." *Círculo* 6 (1977): 27–33.

Conklin, Jeff. "Hypertext: An Introduction and Survey," *IEEE Computer* 20.9 (1987): 17–41.

Cornwell, Jim A. "*The Tower of Babel and Babylon, Gilgamesh, Ningizzida, Gudea.*" 5 March 2006 <http://www.mazzaroth.com/ChapterThree/TowerOfBabel.htm>.

Douglas, Jane Yellowlees. "Are We Reading Yet? A Few Pointers on Reading Hypertext Narratives." Print introduction to *Victory Garden*. Cambridge, MA: Eastgate Systems, 1991.

——. Deleuze, Gilles, and Felix Guattari. *A Thousand Plateaus: Capitalism and Schizophrenia*. Trans. Brian Massumi. Minneapolis: U of Minessota P, 1987.

——. "Maps, Gaps, and Perceptions: What Hypertext Readers (Don't) Do," *Perforations* 3.1 (Spring/Summer 1992).

——. "Are We Reading Yet? A Few Pointers on Reading Hypertext Narratives." Print introduction to *Victory Garden*. Cambridge, MA: Eastgate Systems, 1991.

Deleuze, Gilles, and Félix Guattari. *A Thousand Plateaus: Capitalism and Schizophrenia*. Trans. Brian Massumi. Minneapolis: U of Minessota P. 1987.

Dietz, Steve. Simon Biggs' Babel. 10 August 2005 <http://hosted.simonbiggs.easynet.co.uk/ babel/intro.htm>.

"Digerati." *Merriam Webster Dictionary Online*. 2 April 2005 <http://www.www.m-w.com/ cgibin/dictionary?book=Dictionary&va=digerati&x=4&y=19.

Eco, Umberto. Afterword. *The Future of the Book*. Ed. Geoffrey Nunberg Berkeley: U of California P, 1996.

——. *The Name of the Rose*. Trans. William Weaver. New York: Harcourt Brace and Company, 1984.

——. *The Open Work*. Trans. Anna Cancogni. Cambridge: Harvard UP. 1989.

——. *Opera aperta.* Milan: Bonpiani, 1962.

——. *Semiotics and the Philosophy of Language*. London: Macmillan P, 1984.

Foucault, Michel. "Language to Infinity" *Language, Counter-Memory, Practice*. Ed. Donald F. Bouchard. Ithaca: Cornell UP, 1977.

Genette, Gérard. "La Littérature selon Borges" in *L'Herne* (4): Jorge Luis Borges, Paris: L'Herne 1964. pp. 323

Goldschmidt, E. P. *Medieval texts and their first appearance in print.* New York, Biblo and Tannen, 1969.

Greenberg, Ilan. "A Nnose for Business." *MIT Technology Review.* July/August 1999: 62–67.

Havelock, Eric Alfred. *Preface to Plato.* Cambridge: Harvard UP, 1963.

——. *The Muse Learns To Write* New Haven: Yale UP, 1986.

Hayles, Katherine, ed. "Bodies of Texts, Bodies of Subjects." In *Memory Bites: History, Technology and Digital Culture.* Ed. Lauren Rabinovitz and Abraham Geil. Durham: Duke UP, 2004. 257–282.

——. *Chaos and Order : Complex Dynamics in Literature and Science.* Chicago: The University Of Chicago Press, 1991.

——. *My Mother Was a Computer Machine: Digital Subjects and Literary Texts.* Chicago: U of Chicago P, 2005.

——. "Open Work: Dining at the Interstices," Progressive Dinner Party. 2000. 24 August 2004 <http://califia.hispeed.com/RM/haylesfr.htm>.

Heidegger, Martin. *On Time and Being* Trans. Joan Stambaugh. New York: Harper and Row, 1972.

"Hieroglyphic writing." *Encyclopædia Britannica.* 2006. Encyclopædia Britannica Online. 2 June 2006 <http://search.eb.com/eb/article-53614>.

Holmes, Tiffany. "Art games and Breakout: New media meets the American arcade" 9 August 2005 <http://www.crudeoils.us/artwrite/August2002/Holmes.htm>.

Holquist, Michael. "Jorge Luis Borges and the Metaphysical Mystery." *Mystery and Suspense Writers: The Literature of Crime, Detection and Espionage.* Ed. Maureen Corrigan and Robin W. Winks. New York: Scribner's, 1998. 83–96.

Jaskolski, Helmut. *The Labyrinth: Symbol of Fear, Rebirth and Liberation.* Trans. Michael H. Kohn. Boston: Shambala, 1997.

Joyce, Michael. *afternoon: a story.* Computer Disk. Cambridge: MA: Eastgate, 1987.

——. *Of Two Minds : Hypertext Pedagogy and Poetics.* Ann Arbor: U of Michigan P, 1995.

Kerman, Alvin *The Death of Literature* New Haven: Yale UP, 1990.

Kommers, Piet, A.M, Scott Grabinger, and Joanna C. Dunlap, eds. *Hypermedia Learning Environments: Instructional Design and Integration.* Mahwah: NJ: Lawrence Erlbaum Associates, 1996.

Landow, George. The Victorian Web. 10 December 1999 <http://landow.stg.brown.edu/victorian/victov.html>.

Landow, George and P. Delany, eds. *Hypermedia and Literary Studies.* Cambridge, MA: MIT P, 1990.

——. *Hyper/Text/Theory.* Baltimore: Johns Hopkins UP, 1994.

Lapidot, Ema. "Borges: *Between* the Printing Press and the Hypertext." Paper presented at the International Colloquium Jorge Luis Borges y el pensamiento y el saber en el Siglo XX. Leipzig, March 1996.

Larsen, Deena and R. E. Higgason. "Foundations: An Anatonmy of Anchors." *Proceedings of the Fifteenth ACM Conference on Hypertext and Hypermedia HYPERTEXT '04. Santa Cruz, California. 9–13 August 2004.* April 2006 <http://www.sigweb.org/conferences/ht-conferences-archive/ht04/hypertexts/larsen/noflash/joyce/afternoon.htm>

Lennon, Adrian. *Jorge Luis Borges.* New York: Chelsea, 1992.

Li, T.Y. and J.A Yorke. "Period Three Implies Chaos." *American Mathematically Monthly* 82 (1975): 985.

Lotman, Jurij. *The Structure of the Artistic Text.* Trans. G. Lenhoff and R. Vroon. Michigan Slavic Contributions, 7. Ann Arbor: U of Michigan, Department of Slavic Languages and Literature, 1977.

Luesebrink, Marjorie. *M is for Nottingham.* 17 February 2006 <http://califia.us/NottinghaM/>.

———. "The Simultaneous South: An Electronic, Multilinear approach to Borges' 'The South.'" Paper presented at the annual Modern Language Association convention, San Diego, California. 27 December 2003 <http://califia.us/MLA/introjb.htm>.

Meyer, Tom, Blair, David, and Hader, Suzanne. "A MOO-Based Collaborative Hypermedia System for WWW." *Proceedings of the 2nd International WWW Conference,* 1994.

Miles, Adrian. "Review of Stuart Moulthrop's 'Reagan's Library.'" 15 June 2004 <http://hypertext.rmit.edu.au/essays/rl/>.

Miller, Robin. Interview with William O'Shea. 22 April 1999. 10 August 2005 <http://web.archive.org/web/20011217192738/www.feedmag.com/vgs/re.html>

Monegal, Emir Rodriguez. "Borges: The Reader as Writer." Ed. Charles Newman. Spec. issue of *TriQuarterly* 25 (1972): 102–143

Montfort, Nick. "Introduction: The Garden of Forking Paths." *The New Media Reader.* Ed. Noah Wardrip-Fruin and Nick Monfort. Cambridge, MA: MIT P, 2003. 30–31.

Morgan, Wendy. "Electronic Tools for Dismantling the Master's House: Poststructuralist Feminist Research and Hypertext Poetics." *Proceedings of the ACM Conference on Hypertext.* Ed. J.Legget, K. Tochtermann, J. Westbomke, U. Will. Darmstadt: Association for Computing Machinery, 1999. 207–214.

Moulthrop, Stuart, "An Anatomy of 'forking paths." (1987) New Media Reader. Ed. Noah Wardrip-Fruin and Nick Monfort. CD-ROM. Cambridge, MA: MIT P, 2003.

———. E-mail to the author. 6 Jan. 2000.

———. "Heriscope." (1995–1997) <http://iat.ubalt.edu/moulthrop/hypertexts/hgs>.

———. Personal interview. 3 October 2002.

———. "Pushing Back: Living and Writing in Broken Space." 1997. 16 March 2006 <http://iat.ubalt.edu/moulthrop/essays/pushMe.html>.

———. "Reading from the Map: Metonymy and Metaphor in the Fiction of Forking Path,"in *Hypermedia and Literary Studies.* Cambridge, MA: MIT P, 1991. 120–131.

———. "Reagan Library." CD-ROM in *Gravitational Intrigue,* the *Little Magazine* electronic anthology, 22 (1999).

———.*Victory Garden.* Diskette. Watertown: Eastgate Systems, 1991.

Musarra-Schroeder, U. "Il Laberinto e la rete." *Percorsi Moderni e Postmoderni nell'Opera di Italo Calvino.* Rome: Bulzoni, 1996.

Nahir, Rohit "And Now, Computers You Can Talk To!" 6 April 1999. 26 February 2000 <http://www.financialexpress.com/fe/daily/19990406/fle06078.html>.

Nelson, Ted. *Comp Lib: Dream Machines.* Redmont: Tempus Books of Microsoft P, 1987.

———. *Literary Machines* 93.1 Sausalito: Mindful P, 1992.

Nielsen, Jakob. "Jakob Nielsen's Alertbox." 19 December 2005. 2 Jan. 2006 <http://www.useit.com/alertbox/internet_growth.html>.

Pajares Tosca, Susana. *"Condiciones extremas:* Digital Science Fiction from Colombia," *Latin American Literature and Mass Media.* Ed. Edmundo Paz Soldán and Debra Castillo. New York: Garland, 2001. "The Lyrical Quality of Links" *Proceedings of the ACM Conference on Hypertext.* Ed J. Legget, K. Tochtermann, J. Westbomke, U. Will. Darmstadt: Association for Computing Machinery, 1999. 217–218.

——. "The Lyrical Quality of Links." *Proceedings of the ACM Conference on Hypertext.* Ed J.Legget, K. Tochtermann, J. Westbomke, U. Will. Darmstadt: Association for Computing Machinery, 1999. 217–218.

Paulson, William R. *The Noise of Culture.* Ithaca: Cornell UP, 1988.

Pineda Cachero, Antonio, "Literatura, Comunicación y Caos: Una lectura de Jorge Luis Borges." *Revista Internacional Digital del Grupo de Investigación en Teoría y Tecnología de la Comunicación,* U of Seville, Spain, 2000. April 2005 <http://www.cica.es/aliens/gittcus/700pineda.htm>

Plato. *Phaedrus and Letters VII and VIII.* Trans. Walter Hamilton. London: Penguin Books, 1973.

Porush, David. "Literature as Dissipative Structure." *Literature and Technology.* Ed. Mark L. Greenberg and Lance Schachterle. Bethlehem: Lehigh UP, 1992. 275–306.

Poster, Mark *The Mode of Information: Poststructuralism and Social Context.*Chicago: U of Chicago P, 1990.

Prigogine, Ilya. *Las leyes del caos.* Trans. Juan Vivanco. Barcelona: Crítica, 1997.

Prigogine, Ilya, and Isabelle Stengers. *Order Out of Chaos la Nouvelle Alliance.* Paris: Gallimard, 1979.

——. *Order out of Chaos: Man's New Dialogue With Nature.* New York: Bantam, 1984.

Rettberg, Scott. "The Pleasure (and Pain) of Link Poetics." *electronic book review.* 12 December 2001. March 2006 <http://www.electronicbookreview.com/v3/servlet/ ebr?essay_id=rettbergrip&command=view_essay>.

Riesman, David. *The Oral Tradition, the Written Word and the Screen Image.* Yellow Spring, Ohio: Antioch P, 1956.

Ricardo Francisco and Elin Johane Sjursen. "Behind the Narrative Interface: Aspects of Structure in Hyperfiction." Paper presented at Messenger Morphs the Media 99 workshop in Hypertext 99. The Tenth ACM Conference on Hypertext and hypermedia held in Darmstadt, Germany, February 1999. 10 December 1999 <http://www. netcenter.org/>.

Sarlo, Beatriz. "Borges, a Writer on the Edge." *Borges Studies Online.* 2001. March 2006 <http://www.uiowa.edu/borges/bsol/bsi5.htm>.

——. *Jorge Luis Borges: A Writer on the Edge.* Ed. John King. London: Verso, 1993.

Schreiber, Gabriel, and Roberto Umansky. "Bifurcation, Chaos, and Fractal Objects in Borges' 'Garden of Forking Paths' and Other Writings." *Variaciones Borges* 11 (2001): 61–79.

Slatin, John M. *Reading Hypertext: Order and Coherence in a New Medium. College English,* 52.8 (December 1990): 870–884.

Soderman, Braxton A. "At the Crossroads of the Trivial." *The Electronic Journal of Communicatio*n. 14.1–2.2 (2004).

Strasma, Kip "A Rhetoric of Hypertext Links: Connections to, Within, and Beyond Hypertext Nodes." *Proceedings from CCCC,* held in Washington, DC, 1995.

*The New English Bible with the Apocrypha.* Ed. Samuel Sandmel, M. Jack Suggs, and Arnold J. Tracik. New York: Oxford UP.1976.

Toffler, Alvin. "Foreword." *Order Out of Chaos: Man's Dialogue with Nature.* By Ilya Prigogine and Isabelle Stengers. New York: Bantam, 1984. xi–xxvi.

Venkatagiri, H. S. "Speech Recognition Technology Applications in Communication Disorders." *American Journal of Speech-Language Pathology.* Nov 2002. 11.4 (2002): 323–333.

Walker, Jill. Blog. *Routledge Enciclopedia of Narrative Theory.* Ed. David Herman, Manfred Jahn and Marie-Laure Ryan. London: Routledge, 2005. 45.

Weisstein, Eric W. "Bifurcation." *MathWorld,* Wolfram Web Resource. 3 February 2005 <http://mathworld.wolfram.com/Bifurcation.htm >.

Weissert, Thomas. "Representation and Bifurcation: Borges's Garden of Chaos Dynamics" in Katherine Hayles, *Chaos and Order: Complex Dynamics in Literature and Science* Chicago: U of Chicago P, 1991., 223–243.

Williamsen, Amy. *Co(s)mic Chaos: Exploring Los Trabajos de Persiles y Sigismunda.* Newark: Juan de la Cuesta, 1994. 31.

Worton, Michael and Judith Still. Introduction. *Intertextuality: Theories and Practices.* Ed. Michael Worton and Judith Still. Manchester: Manchester University Press, 1990. 1–44.

# Index

*Riven*, 101–102

Walker, Jill, 12
war narratives, 76–77
Web, the. *see* World Wide Web, the
Web art. *see* net art
Weblogs, 12, 62
Web sites, 12, 62
Weissert, Thomas, 71, 72, 73, 75, 81, 96
Weisstein, Eric W., 94
"words that yield", 77
World Wide Web, the, 2, 5, 9, 40, 51, 53–57,
　60, 61–62, 68–70. *see also* Internet, the;
　net art
Worton, Michael, 53
writer, the, 1, 17–20

Xanadu System, 7, 21n2, 51, 63n1

# LATIN AMERICA
## Interdisciplinary Studies

Gladys M. Varona-Lacey
*General Editor*

*Latin America: Interdisciplinary Studies* serves as a forum for scholars in the field of Latin American Studies, as well as an educational resource for anyone interested in this region of the world. Themes and topics encompass social, political, historical, and economic issues, in addition to literature, music, art, and architecture.

For additional information about this series or for the submission of manuscripts, please contact:

Dr. Gladys M. Varona-Lacey
Ithaca College
Department of Modern Languages & Literatures
Ithaca, NY 14859

To order other books in this series, please contact our Customer Service Department at:

(800) 770-LANG (within the U.S.)
(212) 647-7706 (outside the U.S.)
(212) 647-7707 FAX

Or browse online by series at:

WWW.PETERLANG.COM